LAWREN HARRIS

W9-BBB-694

Macmillan of Canada Toronto

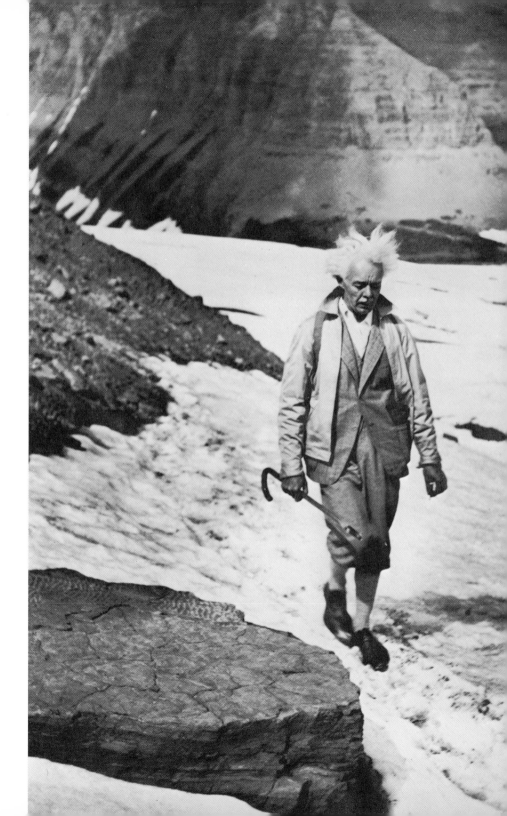

LAWREN HARRIS

Edited by Bess Harris and R. G. P. Colgrove
and with an introduction by Northrop Frye

©The Macmillan Company of Canada Limited 1969

All rights reserved. The use of any part of this
publication reproduced, transmitted in any form
or by any means, electronic, mechanical, photo-
copying, recording, or otherwise, or stored in
a retrieval system, without prior consent of the
publisher is an infringement of copyright law.

First edition 1969
First paperback edition 1976

ISBN 0 7705 1453 7

Printed in Canada by Herzig Somerville Ltd. for
The Macmillan Company of Canada Limited.

Grateful acknowledgment is made for permission to include reproductions of paintings from the private collections of the following: C. S. Band of Toronto – 'Miners' Houses, Glace Bay' and 'Riven Earth II'; H. Spencer Clark of Toronto –'Icebergs, Davis Strait'; R.G.P. Colgrove of Toronto –'The Bridge' and 'In Memoriam to a Canadian Artist'; J. C. Fraser of Toronto –'Houses'; E.R. Hunter of Florida – 'Thoreau MacDonald'; Michael M. Koerner of Toronto – 'From the Harbour to the Open Sea'; Dr. J. A. MacAulay of Winnipeg –'Lake Superior IX'; Miss Isabel McLaughlin of Toronto –'Riven Earth I'; Colonel R. S. McLaughlin of Oshawa – 'Pic Island, Lake Superior'; and S. C. Torno of Toronto – 'Isolation Peak' (sketch).

Most of the photography for this volume was done by John Evans of Ottawa, Eberhard Otto of Toronto, and Selwyn Pullan of Vancouver.

Preface

Here is the working life of Lawren Harris. Painting is not an entertainment or an occupation for him; it is a communicative way of life. The paintings have been chosen to show the range of the work produced during the years from 1910 to 1968. Writing was, for him, a means of clarifying thought, of sorting out observations, and of sifting ideas. The text is made up of selections from his writings – published articles, notebooks written between the years 1920 and 1960, and *Contrasts*, a volume of poems published in 1922. The selection and arrangement of the paintings has been made by Bess Harris, and of the text by R. G. P. Colgrove.

Introduction by Northrop Frye

As a rule, when associations are formed by youthful artists, they break up as the styles of the artists composing them become more individual. But the Group of Seven, who did so much to revitalize Canadian painting in the twenties and later of this century, still retain some of the characteristics of a group. Seven is a sacred number, and the identity of the seventh, like the light of the seventh star of the Pleiades, has fluctuated somewhat, attached to different painters at different times. But the permanent six, of whom four are still with us, have many qualities in common, both as painters and in fields outside painting. For one thing, they are, for painters, unusually articulate in words. J. E. H. MacDonald and Lawren Harris wrote poetry; Harris, as this book shows, wrote also a great deal of critical prose; A. Y. Jackson produced a most entertaining autobiography; Arthur Lismer, through his work as educator and lecturer, would still be one of the greatest names in the history of Canadian art even if he had never painted a canvas. For another, they shared certain intellectual interests. They felt themselves part of the movement towards the direct imaginative confrontation with the North American landscape which, for them, began in literature with Thoreau and Whitman. Out of this developed an interest for which the word theosophical would not be too misleading if understood, not in any sectarian sense, but as meaning a commitment to painting as a way of life, or, perhaps better, as a sacramental activity expressing a faith, and so analogous to the practising of a religion. This is a Romantic view, following the tradition that begins in English poetry with Wordsworth. While the Group of Seven were most active, Romanticism was going out of fashion elsewhere. But the nineteen-sixties is once again a Romantic period, in fact almost oppressively so, so it seems a good time to see such an achievement as that of Lawren Harris in better perspective.

This remarkable book presents a fine selection of Lawren Harris's paintings in the context of the various speeches, essays, poems, letters, notebook jottings, and drafts of books by which he tried to express his conception of art as an activity of life, and not something separable from it. What he says forms the context of the paintings, and the paintings form the context of what he says. Much of what he says might seem over-general or lacking in applicability if we did not see it, with the expert and patient help of the editors, as specifically illustrated by the painting. An example is the placing of his painting 'The Bridge' beside a number of statements about art as various forms of a bridge. Even

so he has some difficulty in saying in words what he says so eloquently in the pictures. One reason for this is that our language is naturally Cartesian, based on a dualism in which the split between perceiving subject and perceived object is the primary fact of experience. For the artist, whatever may be true of the scientist, the real world is not the objective world. As Shelley, another Romantic, insisted, it is only out of laziness or cowardice that we take the objective world to be the real one. The attempt to produce a 'realism' which is only an illusion of our ordinary objectifying sense leads to insincere painting, technique divorced from intelligence. But, says Harris, art is not caprice either. The artist, unlike the psychedelic, does not confuse the creative consciousness with the subjective or introverted consciousness. Fantasy-painting becomes insincere also whenever it evades the struggle with the material which is the painter's immediate task. The genuine artist, Harris is saying, finds reality in a point of identity between subject and object, a point at which the created world and the world that is really there become the same thing.

In Harris's earlier works, the paintings of houses and streets in Toronto and the Maritimes and that extra-ordinary piece of Canadian Gothic, the portrait of Salem Bland, we are struck at once by the contemplative quality of the painting, by the intensity with which the painter's whole mind is concentrated on his object – or, as the curious vagaries of language have it, his 'subject'. Because of this meditative intensity, the painting is representational. But it is very far from what is often called photographic realism, although what this phrase usually refers to is just as bad in photography as it is in painting. The sombre, brooding miners' cottages and the bizarre lights and shadows of a Toronto street, with their unpredictable splashes of colour (deftly illustrated by the editors in placing one of the painter's poems beside a similar picture), stare at us with an emotional intensity which ordinary eyesight cannot give us. This intensity is, of course, the kind of thing we turn to pictures for. But neither do we have the feeling that this emotional power is simply there as a reflection of what the painter felt and was already determined to impose on whatever he saw. Such paintings are the painter's inventions, a word which means both something made and something found. There is tension and struggle between the act of seeing and the resistance of the thing seen: we who see the picture participate in the struggle, and so make our own effort to cross the *pons asinorum* of art, the 'bridge' between the ordinary subject and the ordinary object.

Lawren Harris makes it clear that what drove him and his colleagues out to the northern part of Canada was

their distrust of the 'picturesque', that is, the pictorial subject which suggests a facile or conventional pictorial response. His paintings of Lake Superior and the Rockies are as much of an exploration as the literal or physical explorations of La Vérendrye or Mackenzie. Harris remarks on the 'austerity' of nature: she does not tell the artist what to do; she speaks in riddles and oracles, and the painter is an Oedipus confronting a sphinx. He also insists on how necessary it was for him, as for his associates, to seek a three-dimensional grasp of what MacDonald called the 'solemn land', to avoid the merely decorative as he avoided all other forms of pictorial narcissism, the landscape which is merely in front, looked at but not possessed. A picture has to suggest three dimensions before it can suggest four, before the object can become a higher reality by becoming also an event, a moment suspended in time.

It has been said of some Canadian painters, notably Thomson, that their sketches are often more convincing than the worked-up picture. The former gives more of a sense of painting in process, as an event in time, as a recording of the act of vision, and the final picture, it is said, sometimes becomes monumental at the expense of vitality and immediacy. The editors have juxtaposed some paintings with their preparatory sketches so that the reader can judge for himself as regards Lawren Harris.

But there is no doubt that this painter felt the tension between process and product of painting, and that his logical development from stylized landscape to abstraction was his way of escaping from it.

In the abstract paintings the rudiments of representation are still there, with triangle and circle replacing mountain and horizon; but the stylizing and simplifying of outline have been carried a step — perhaps one should say a dimension — further. The more dependent a picture is on representation, the more epigrammatic it is, and the more it stresses the immediate context, in space and time, of a particular sense experience. The effect of stylizing and simplifying is to bring out more clearly, not what the painter sees, but what he experiences in his seeing. Abstraction sets the painter free from the particular experience, and enables him to paint the essence of his pictorial vision, with each picture representing an infinite number of possible experiences. The units of the picture have become symbols rather than objects, and have become universal without ceasing to be particular.

Traditionally, the metaphor of the magician has often been used for the artist: the Orpheus whose music moved trees, the Prospero whose fancies are enacted by spirits. The kernel of truth in the metaphor is that the artist's mind seeks a responding spirit in nature (Harris

speaks of 'informing cosmic powers' in his landscapes). This responding spirit is not a ghost or a god or an elf like Puck, but the elemental spirit of *design*, the quality in nature which for the artist, as for the scientist in a different way, contains what can be identified with the searching intelligence. Such design is often quasi-geometrical in form – the 'books' of Prospero that Caliban so feared and hated would have been, being magic books, full of geometrical and cabalistic designs. This geometrical magic has always been an informing principle of painting, though it was probably Cézanne who was most influential in stressing its importance for the modern painter. There are many kinds of abstract painting: those that are clear and sharp in outline emphasize the rigorous control of the object by the consciousness; others express rather a sense of the inner power of nature, the exploding energy that creates form. Both kinds are prominent in, for instance, Kandinsky. Most of Lawren Harris's abstractions reflect a strict conscious control of experience, as one would expect from the clarity of outline in the landscapes that preceded them. But in the two remarkable 1967 paintings reproduced near the end of the book, there is a sense of a relaxation of control, as though the informing cosmic powers themselves were taking over from the painter.

After the conservative stock responses to the Group of Seven ('hot mush school' and the like) were over, there followed radical and left-wing stock responses which accused them of the decadent bourgeois vice of introversion, turning their backs on society and its problems to develop their own souls in the solitudes of the north. I even remember a Communist magazine which asserted that to find the true revolutionary tradition in Canadian painting we should go back to the Victorian anecdotal painters. One thing that will strike the reader of this book at once is the painter's social concern, a concern which actually increases as he goes further into abstract techniques. The first and most important of his 'bridges' is the bridge between the artist and his society. He is missionary as well as explorer: not a missionary who wants to destroy all faith that differs from his own, but a missionary who wants to make his own faith real to others. Just as a new country cannot become a civilization without explorers and pioneers going out into the loneliness of a deserted land, so no social imagination can develop except through those who have followed their own vision beyond its inevitable loneliness to its final resting place in the tradition of art. The record of an imaginative journey of remarkable integrity and discipline is what is commemorated in this book.

1968

LAWREN HARRIS

Summers

...lney Summers lives and paints in Red
..., Colorado, a small town high in a
...untain valley.

... most of her life, Sydney has painted.
...e began to paint professionally in 1974
...en she and a dear friend opened a
...ery in their home. This evolved into a
...ve to the Vail Valley in 1980 and the
...ginning of Mountain Ironworks and
...lery, where Sydney is a partner and
...ows her work.

...paint because it is a way to express a
...rt of me that I can express in no other
...y." she says. "I like the softness and
... fluidity of paint on paper. So much
...opens when I get the paper wet and
...ow the paint to help me make the pic-
...e. I like people to use their imaginations
...en they look at my work, and to be one
... he creators of the paintings, too."

...dney enjoys meeting the people who
...y her art, and hopes they enjoy having
... work as much as she enjoyed creating

SYDNEY SUMMERS
741 S. Main, Box 460
Minturn, Colorado 81645
827-4226 827-5881

...from introductions by Lawren Harris for a book he was planning

3

...proach the subject of art from the point of view of consciousness, of interior
...or spiritual viewpoint that lies behind the aesthetic viewpoint.
...it has myriad phases, and the approaches to it are as varied as the char-
...truth in terms of the physical, the sensual, the naturalistic and mechanistic,
...response, and truth in terms of the intellect, and truth in terms of the
...nd intelligence.
...pirit, just as there is a realism of the flesh and forms, and what we term
...the dynamic bridge between these two, reaching out from the soil of
...tter and its encasing forms, toward the life of the spirit that informs these

...earch, an endeavour to suggest that there is a realm of spiritual realism
...t, and gives to art – and can give to life – a meaning that answers the higher

...und an intuitional creative seeing, and its object is not to present a system
...r activity and a stimulus to awareness. It is written for those who want to
...o know and tabulate. If it is full of contradictions, so is life, and so is all
...encing. These contradictions can only resolve themselves in increased inner
... condemn the book; viewed creatively, they make it.

4 Any definite creative effort draws forth from within the individual something which begins to bridge the gap between himself and the spirit in mankind.

The arts are a bridge between the possessive, acquisitive, profit-making instincts of mankind and the free realm of the spirit.

Art criticism may try to bridge the gap between the artist and the public by bringing the public to understand the artist's purpose, the means he uses to achieve it, and whether the means are adequate to his aim or not.

Creative life is a dynamic bridge between opposites – an interplay – a weaving – dark and light, warm and cold, sharp and soft, conservative and radical, material and spiritual, neither of them right, and yet both necessary.

An engineer builds a bridge – and when it is completed and he surveys the thing he has designed and sees that it is not only adequate for its purpose, but sees that the bridge expresses it, then he is thrilled. He is thrilled not so much at the usefulness of the bridge but at its expression of function, of meaning – its spiritual side, as it were. And that thrill is the thrill of art. Now, in this we see two realities: the reality of the bridge as a means of crossing over a river, and its reality as expression – its reality as symbol, which can stir us inwardly. Thus we have an outer reality and an inner reality of *response* to such objects, and to all scenes of the outer world. Both are real and the story of their interplay is in part the story of the arts.

The Bridge 1937

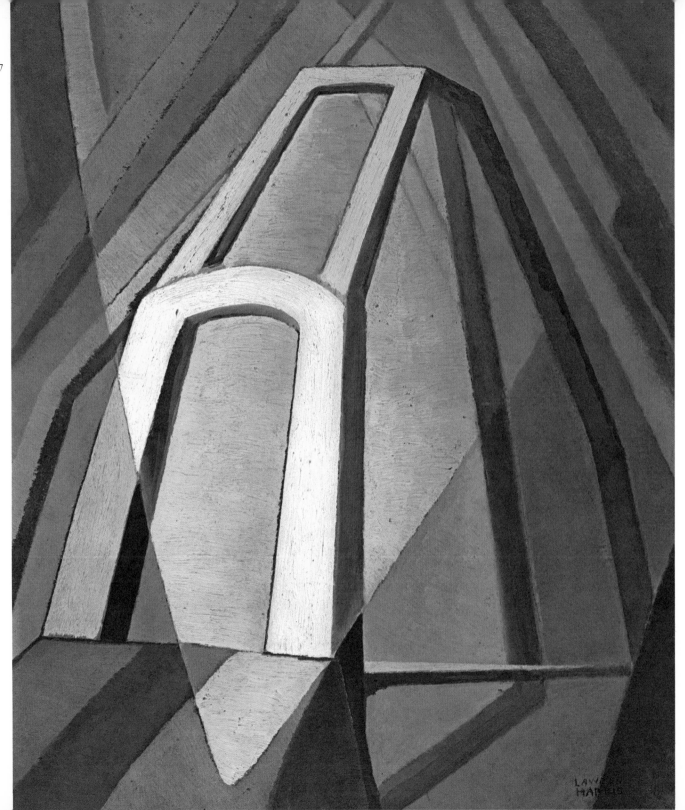

My work was founded on a long and growing love and understanding of the North, of being permeated with its spirit. I felt the strange brooding lonely presence of nature fostering a new race, a new age, and as part of it, a new expression in art. It was an unfolding of the heart itself through the effect of environment, of people, place, and time. No man is profound enough to explain fully the nature of his own inspiration – he generally attributes it to a thousand and one extraneous things. To the artist, his art is adventure in which he seeks to regain unity with nature and the knowledge of his own immortal being.

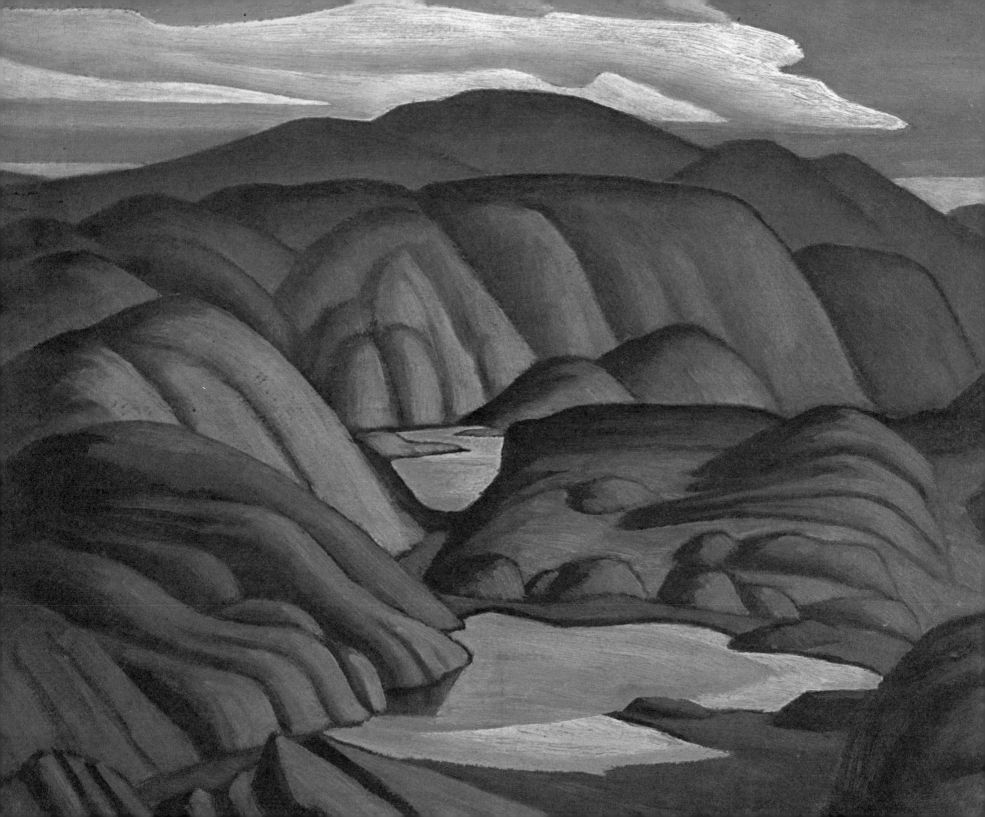

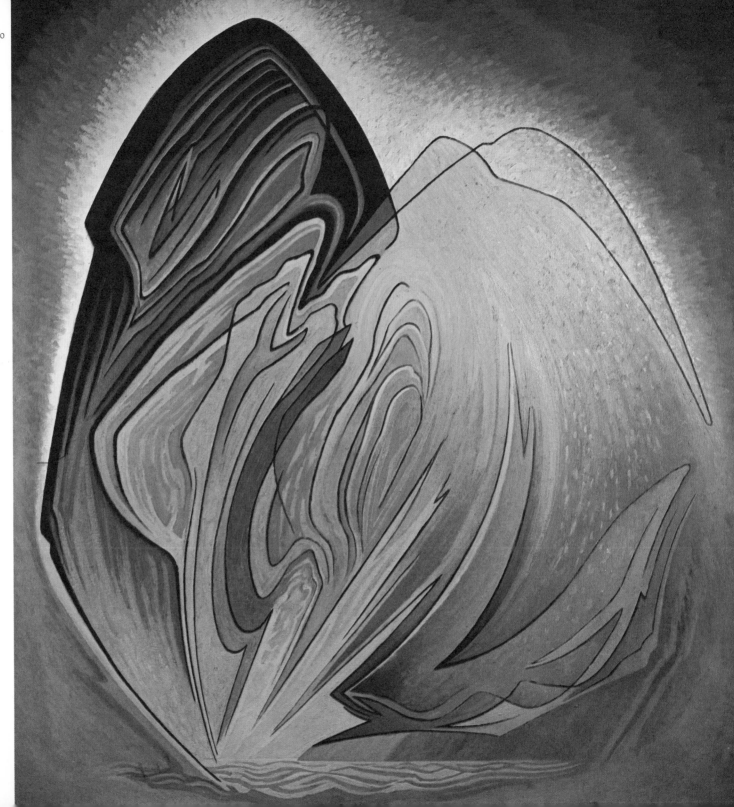

You cannot sever the philosophy of the artist from his work. You belittle the man in his work when you accept his skill, his sensitivity in patterning, in building forms, his finesse in accenting, his suavity in technique, but reject his philosophy, his background. People do this through fear or incapacity to accept life. Without the philosophy, or in other words the man, in the work of any great artist, you have nothing.

Most art critics consider that artists are incapable of expressing themselves in words about painting. Similarly, most artists consider the fulminations of art critics to be a mere weakness engendered by non-creativeness and their unquenchable craze to categorize – the futile application of the slide-rule to the immeasurable and the imponderable.

These two facts should leave me free to say my say, and also leave you free to consider what I have to say as of no consequence.

In the language of art, every shape and colour, every relationship of shapes and colours, line and volume has meaning and significance, but not a meaning which can be put into words.

Art is a life – or a religion, if you will – which rejects nothing, and is therefore essentially robust and full-rounded.

It seeks and finds beauty in tragedy, in mis-fires, the weak, the strong, in squalor and filth; behind all horrors tangible and intangible art finds harmony, and it establishes the permanent.

Art cannot be defined or explained in words because it is a state of mind which must first be created in the individual before it can be comprehended at all; and, once felt, definitions and explanations are no longer necessary.

For the last hundred years and more in Europe, art has derived from the collections in museums, galleries, and palaces; the European artist has been moved by works of art as much as by nature or mankind. But in Canada, with little or no tradition and background, our creative individuals find new adventures in imaginative and intuitive living. The land is mostly virgin, fresh and full-replenishing. This North of ours is a source of spiritual flow which can create through us.

Any new venture in painting — painting in terms of the background in this new, wild, and vigorous land — was considered not proper, not respectable. But creative life always transcends the bounds of the conventional — it is by far too exciting, too great a heightening of the powers in us, productive of too great an enthusiasm to remain in such bounds.

Native subject matter dictates its own handling for its expression, particularly in the attitude created by the clarity of the North for its understanding — the North as a source of a flow of beneficent informing cosmic powers behind the bleakness and barrenness and austerity of much of the land.

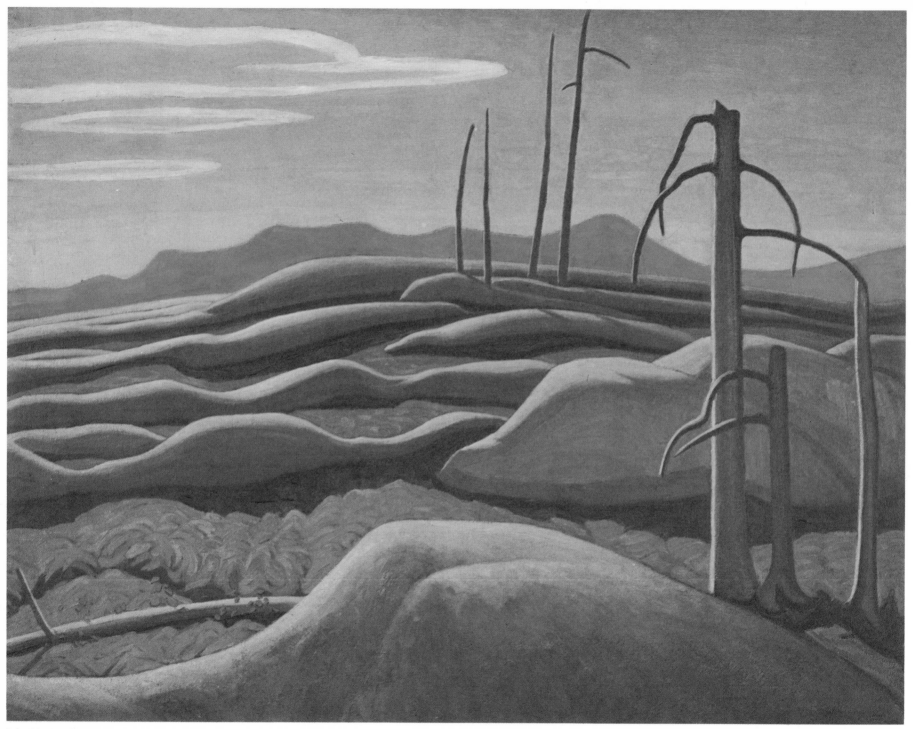

Lake Superior IX 1923

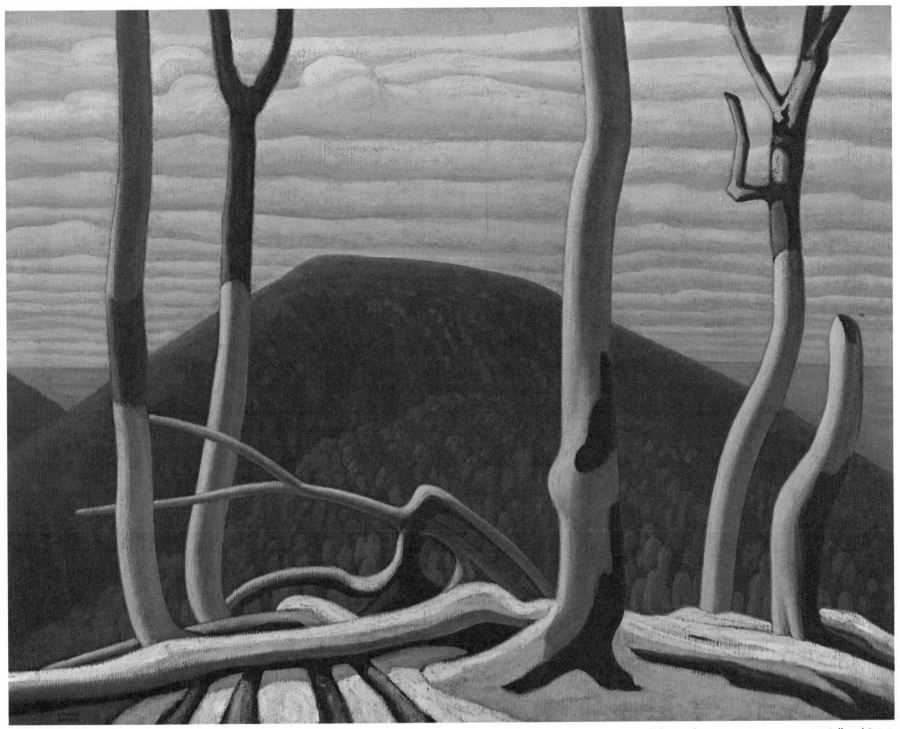

Above Lake Superior 1924 *Art Gallery of Ontario*

14 Art, as is true of all man's profound experiences, is not for art's sake, nor for religion's sake, nor for the sake of beauty, nor for any 'cause'. Art is for man's sake. It may be for one man's sake, or two billion. Man, the artist, creates for himself as a living part of mankind.

Real art never seeks factual truth. It seeks to express the character and spirit of a scene in its own plastic language: not the branch of a tree, but the urge of its growth. Yet, art is not caprice; art is essentially organization and order.

Every work of art which really moves us is in some degree a revelation – it changes us. Experiences, much more important than instruction, are a seeing with the inner eye – finding a channel into our essential inner life, a door to our deepest understanding wherein we have the capacity for universal response.

Art is concerned primarily with relationships. The harmony, the order of art, its organization as a living power that can work within us, depends on its inner relationships. It is an epitome of the cosmic order in one sense – of many parts, factors, phases, and meanings functioning together as one living whole. We must share in its life, in the sense that it was said that 'All the morning stars sang together.'

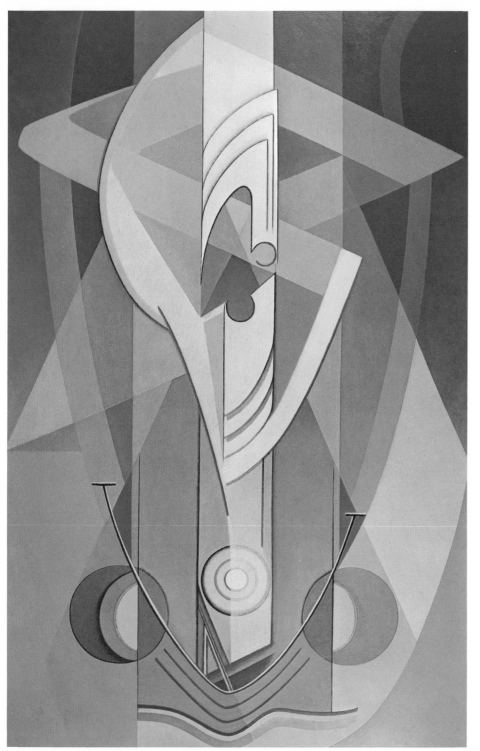

Abstraction 1938

16 If we are to give a deeper meaning to all professions and occupations than inheres in them and make the best use of the great discovery of science, we must have and apply a standard which lies outside and beyond all of these, and the only standard we can apply – if we are to serve the highest ends – is one of the spirit.

We are all aware that the principles of the spirit function in that part of our consciousness which is beyond physical concerns and responses – that part which has an affinity for higher values. These have to do with a sense of justice in life, and its equivalent – fine proportions in art, and the appropriateness of these to the motif or theme; with integrity in life and art and with individuality, responsibility in thought and deed, and its equivalent – creative inevitability in art. Above all, we are aware in our moments of keenest insight that spirit is one, however varied and limitless its expressions, and life and art are therefore interdependent in all their phases.

The principles of the spirit may be a reflection in us of universal harmony – of a dynamic equilibrium at the very heart of universal life. They are the only guide we have in making anything on earth fine, just, harmonious, and meaningful, and they are the motivating impulse, the very basis, meaning, and value of art.

from 'The Fallacy That Art Is Separate from Life'

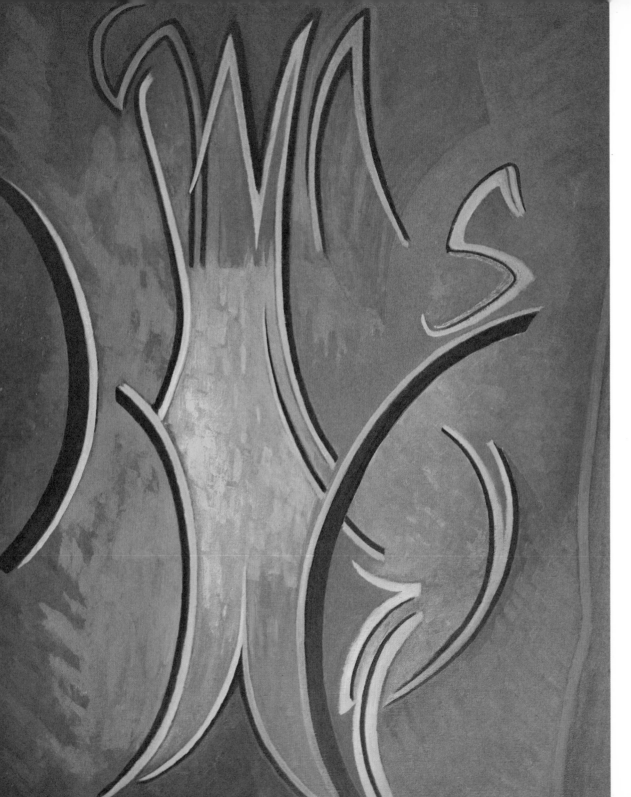

Abstraction 1950

18 Two different approaches to art – the intellectual and the living or intuitional – give rise to a great many misunderstandings and quarrels about works of art. Really the pertinent question is not 'What does it mean?' but 'What experience does it contain?' For a real work of art exists to engender a certain kind of life within us. Its power is to evoke, to enhance, to develop depths and heights of experience we have not had, or to develop those experiences we have already had to greater depths of understanding. Its function is to enlarge our consciousness, to sharpen, intensify, and deepen our awareness, and to increase our range of experience.

Maligne Lake, Jasper Park 1c
The National Gallery of Canada

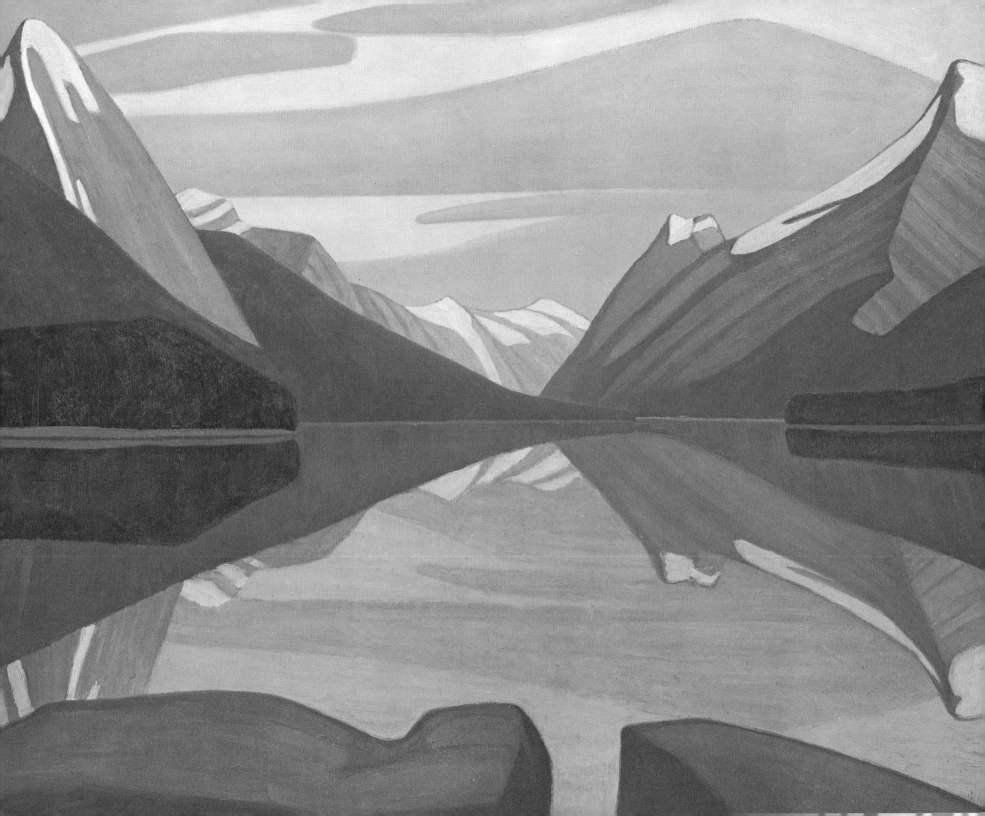

Inspiration, if it is to amount to anything more than a pleasant experience, that is, if it is to be put to real use for the benefit of human beings – and that certainly is its purpose – must come as high moments in the momentum of work. It results from a habit of awareness, a habit of positive receptivity, that is, a receptivity that is actively transforming, that looks for ideas and impressions and high visions as grist for the creative mill. This attitude is quite different from the one wherein inspiration is no more than a means of indulgence, wherever it is a mediumistic pleasure, seemingly fortuitous.

The positive creative attitude is above its inspirations, that is, while the joy of the moment's increase of vision is great, there is the greater and more constant urge of using it to purge the mind of dross, to keep the soul in the realm of clearer perceptions, of finer relationships, to accelerate the faculties for the purpose always of doing something, initiating new work. In other words, ever to keep moving toward a more encompassing vision, a profounder realization of the rhythm of life and its informing eternal spirit, always by work.

Work alone will lift one above personal tribulation, out of the realm of doubt, beyond the place wherein one indulges in little grievances and wails over inconsequential things. Work may be anything from fashioning something with the hands to the constant use of perception thrust into all life, all phases, seeking the secret unity of spirit, the realm of eternal brotherhood.

All created objects, from a hammer to a symphony, are the result of inner momentum, the workings of the heart and mind. It is the constant moving interplay of all faculties that is creative, and these inevitably synchronize to vision, to perceptions of relationship, of unity, of harmony far greater than the moment's harmony of the active heart and mind. In other words, when the lesser functions in service to that which is greater than itself, it surely moves toward illumination.

Dormant faculties are of no use either to their possessor or to life generally. Inactivity actually shuts the individual off from any clear seeing, and holds him in the realm of the hard, broken-up, selfish, sorrowful, hopeless surface of life wherein doubts and cynicism and sterility are engendered.

Surface life – objective existence – is then seen in all its indifference and harshness, unillumined by that which is greater than itself – a myriad of rattling shells with no

coherent life. The infiltration of spirit into matter, of harmony, which is of the spirit, into the chaos of appearances being the creative task of all individuals, it is not merely prostitution of powers to forgo this but an utter loss of that which might prove valuable to the growth of the soul, and the movement of men toward wisdom and understanding.

Now, every civilization has a pace, a momentum, an ascent, as it were, toward its expressive peak where if it achieves this peak it experiences a fullness of life equal to its capacity – a momentary equilibrium wherein it reflects and participates in universal order, and life is lived in terms of that order. All creative life in man anticipates that order. All great and real works of art embody it.

This movement or momentum occurs in the life of every creative individual. If not thwarted, he also ascends to the peak of his expressive, communicative vision and participates in the enduring motion of universal life and order and leaves works that do not describe that order but embody it as an immediate self-contained experience.

That ascent toward fullness of life, wherein a people or an individual participates in the life of universal order and finds release in a greater and more inclusive consciousness, is something that cannot be contrived because the motivating creative urge lies deeper than intellect or reason; it is an inner unfolding.

from 'Momentum'

The informing and moving spirit in all the arts is a power
at work within us, for everything we do comes under
the heading of art. Throughout the ages, art has fash-
ioned the finest and most enduring works of man, the
best of which embody the whole culture of a people,
its aspirations and vision.

The world for us is what our perceptions make of it; all
things are for us just exactly as our particular experiences
and limited sensibilities permit us to see them. The
great creative task of art, then, is the freeing and
expansion of consciousness.

There is no strictly material justification for the arts
except in their lowest level as entertainment and dec-
oration. All the reasons for the value of the arts above
that level have to do with the spirit which taps the
highest resources and faculties in man's nature, and
creates all great cultures.

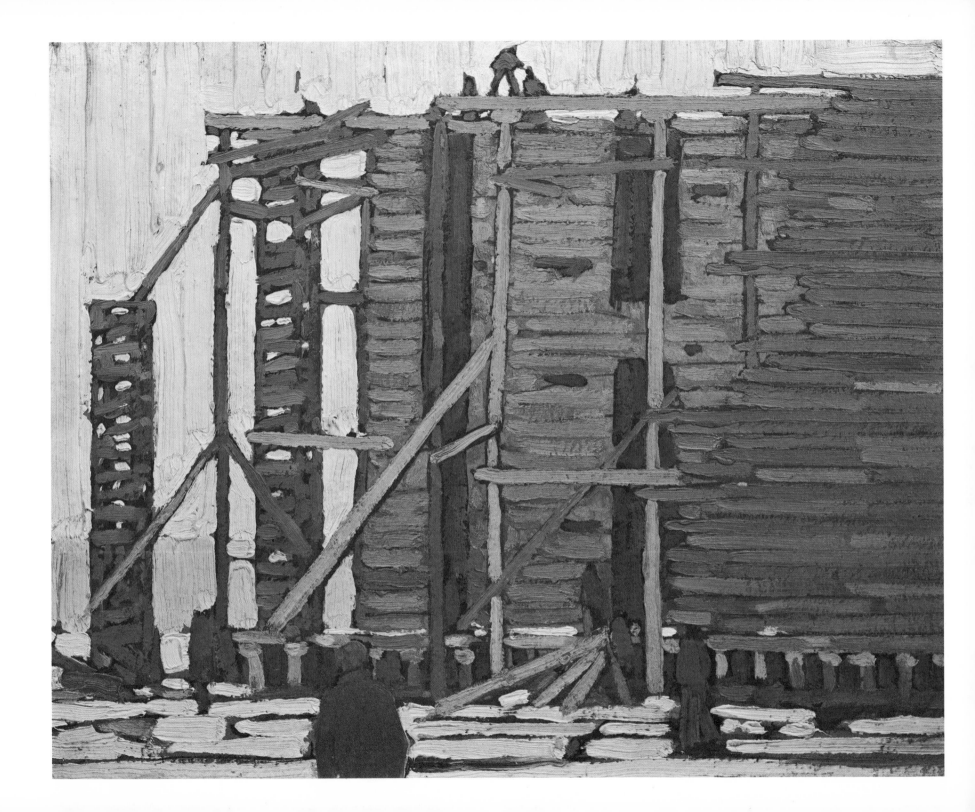

24 Creatively one can only move from and through the particular to the universal, and to achieve universal expression one must give oneself fully to the particular. This is obvious in the process of creating in any art. Thus, if I paint a house, say in a back street in Hamilton, I assume the shape of that particular house, experience its form, its meaning, its relationship to the soil it rises from, the skies that bathe it in reflection of their colours and mood, the neighbouring houses, the mood of the particular house, its age, its inner life; and the more direct my experience of that is, the more I permit that house to dictate to me how I shall paint it and the more certain I am to arrive at pure experience in my art and to create an intense equivalent in terms of my art of my first-hand experience. If my experience is clear and deep enough, the life I get into my picture of that house and the formal relations it dictates for its own expression will become universal.

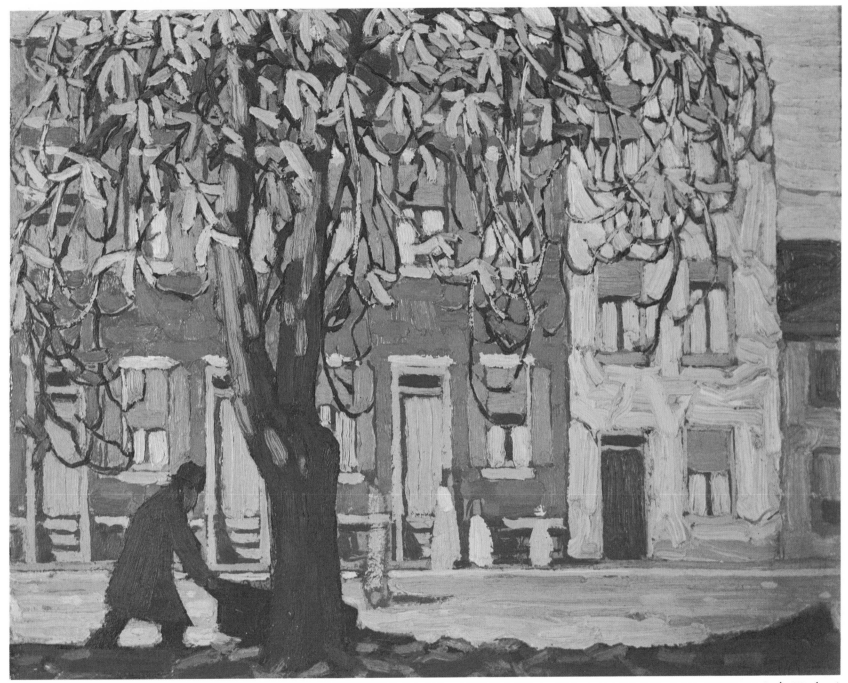

In the Ward 1916

26 The picture of the house, its life expressed by the particular relationships of forms, colours, lines, rhythm, is then bound to bring to life in the spectator, myself firstly, the experience of all life in decrepit houses. But, if I think of achieving a universal expression in my picture, I will get a relatively shallow expression; for I must feel and think and identify myself with that particular, and then the process once started will move me quite naturally and unconsciously toward a universal expression if my capacity is great enough.

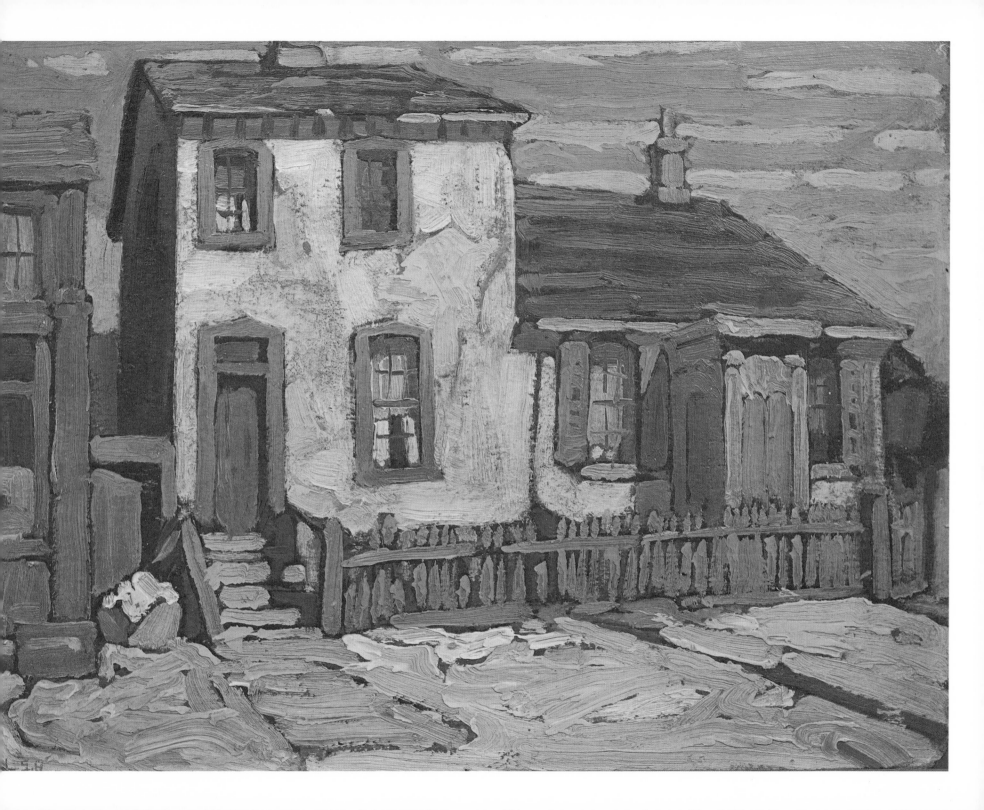

In a part of the city that is ever shrouded in sooty smoke,
 and amid huge, hard buildings, hides a gloomy house
 of broken grey rough-cast, like a sickly sin in a callous
 soul.
Streams of wires run by it wailing in the murky wind.
Two half dead chestnut trees, black and broken, stand
 wearily before it, subdued by a bare rigid telephone
 pole.
The windows are bleary with grime, and bulging, filthy
 rags plug the broken panes.
Torn blinds of cold judas green chill whatever light sifts
 through the smoky air.
Dirty shutters sag this way and that like dancers suddenly
 stopped in an aimless movement.
But the street door smiles, and even laughs, when the
 hazy sunlight falls on it —
Someone had painted it a bright gay red.

from Contrasts, 1922

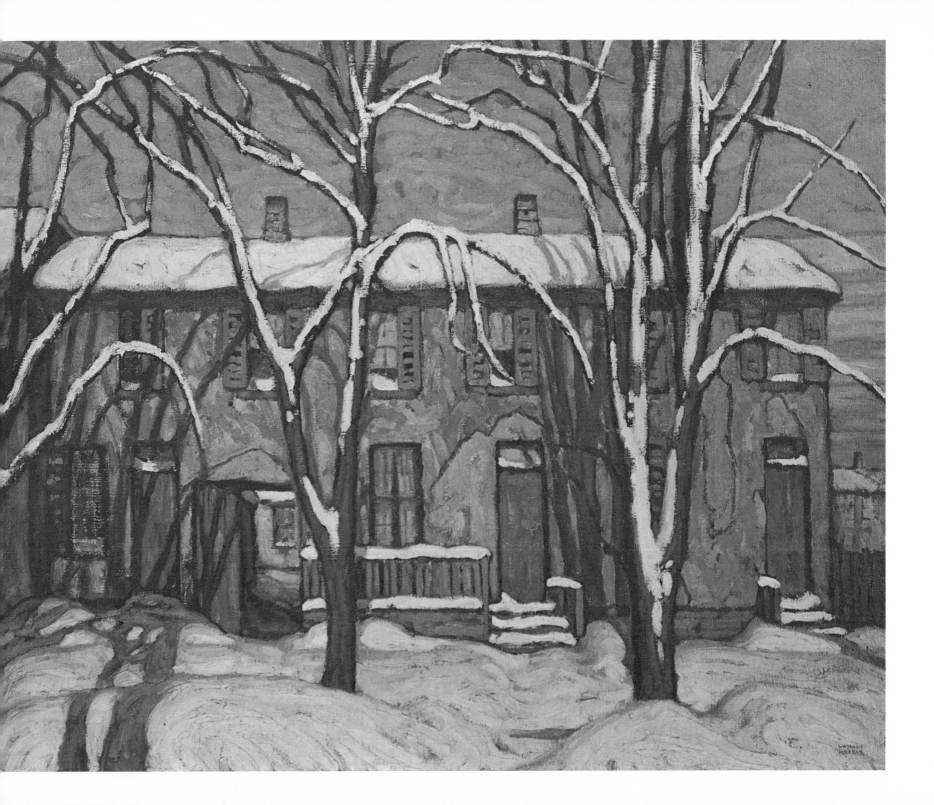

Shacks 1919
The National Galle
of Canada

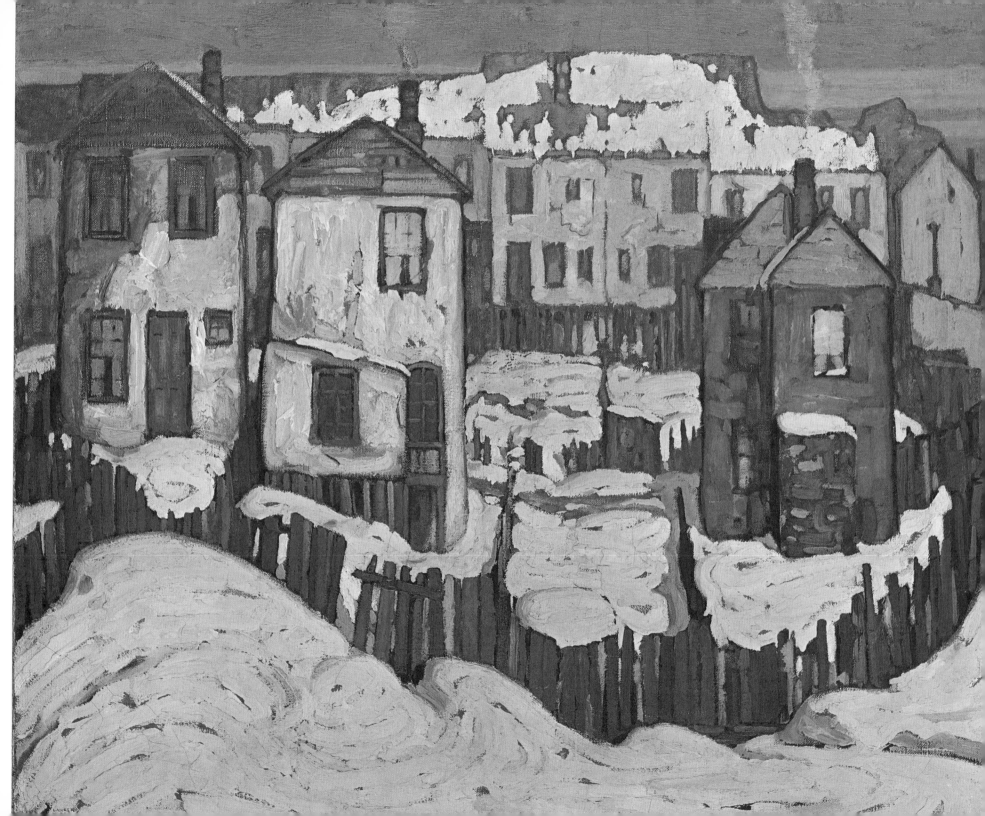

No poem written in recent years has caused so much discussion as 'The Waste Land' by T. S. Eliot. . . .

Here is the disillusioned, fearless, and penetrating vision of the true modern, the facing and acceptance of surface facts, and the amazing agility and swiftness of the mind of today that sees through these facts and through moods and incidents of whatever kind to a majestic and eternal background. Here also is the modern search for symphonic style, many melodies, dissonances, and bits of severe or melancholy music moving together to form one great unified whole. But, and I believe this to be essential to an understanding of the poem, the relationship, the unity, is interior and not to be found by gazing on its incidents and changing style. All parts of the poem are held together by a swift, clear, inner seeing that is beyond time and the usual idea of distance. One has to look for a new manner of vision, a new deftness of thought that follows that vision and is obscure and strange and unpleasant to old and grooved ways of thinking, but is searching, fresh, and inspiriting to modern awareness. . . .

A dismal, a desolate, a heart-breaking picture, but with vision, with in parts strangely beautiful music, with deep feeling, and with a touch of true greatness. For the poet leaves our time and all times; deep within and behind the incidents, the forms, and the language he gives a glimpse of eternal beauty whose ways are not time's ways and whose splendour is not of time but is only to be apprehended in the timelessness of a moment's ecstasy.

from 'T. S. Eliot's Tone Poem', 1923-4

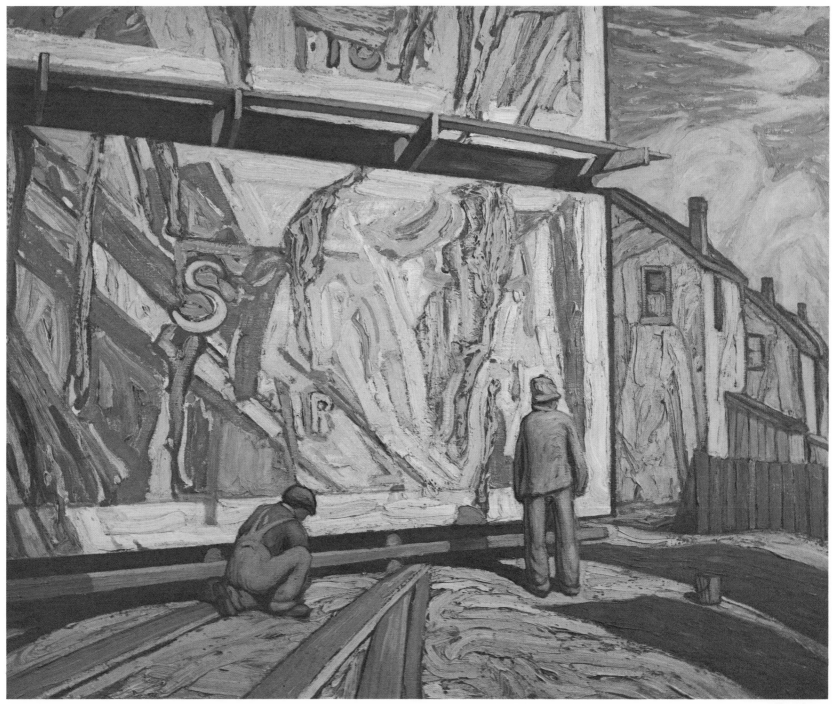

Billboard 1922

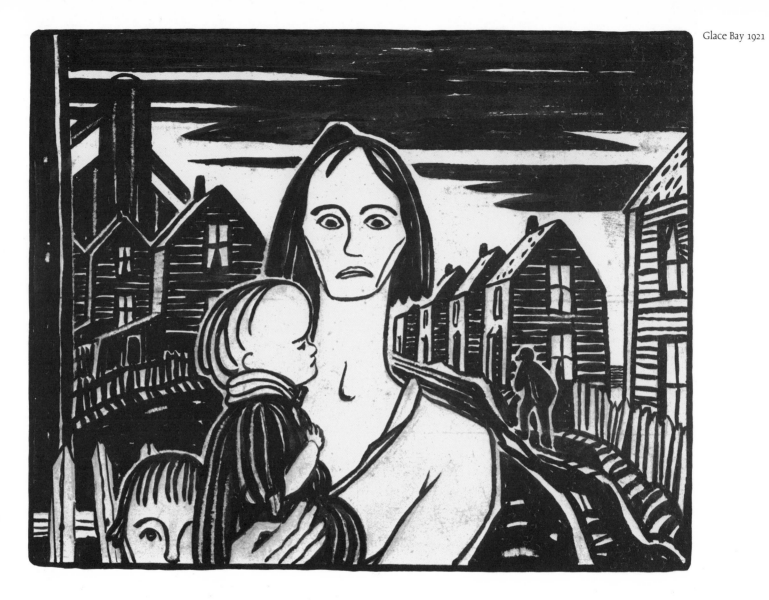

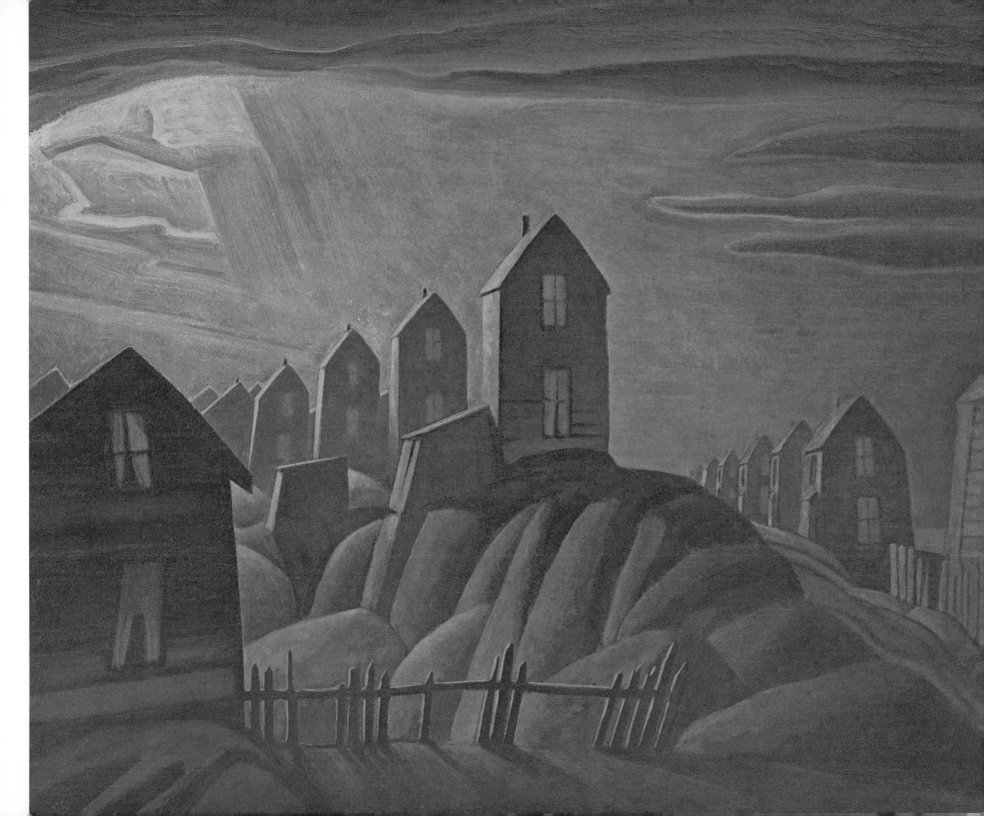

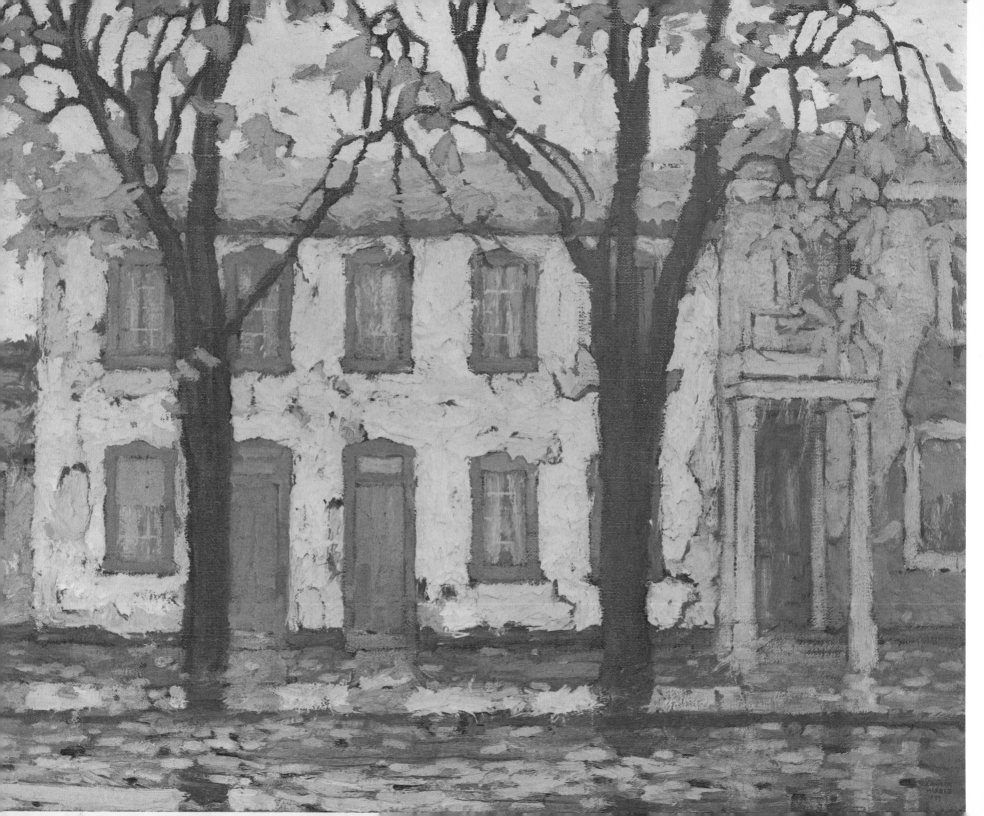

My early paintings of houses were found ugly and inexcusable by some, and true and moving by others. When they were left behind, and the Northern scene — the Algoma and Lake Superior paintings — appeared, many people became sentimental over the earlier street and house paintings and expressed the wish that I had continued to paint these. Each new venture caused similar reactions, and each in turn became more or less acceptable when I had moved to other fields.

The artist moves slowly but surely through many transitions toward a deeper and more universal expression. From his particular love, and in the process of creating from it, he is led inevitably to universal qualities and toward a universal vision and understanding. These are the fruits of a natural growth having its roots deep in the soil of the land, its life in the pervading and replenishing spirit of the North, and its heart-beat one with the life of its people.

Firstly, we were led by the attraction of the North to copy nature. There was a long devotion to her outward aspect until a thorough acquaintance with her facts of form and growth was achieved, an understanding of her streams, rivers, lakes, and many various places, and an assimilation of her many moods and a growing awareness of her presence through the endless diversity of her expression.

This living in and wandering the North, and more or less literally copying a great variety of her motives, inevitably developed in the artist a sense of design, of selection and arrangement in conformity to her aspect and moods, developed from the expressions of her life, a knowledge of her rhythms, an understanding of her ways.

Algonquin 1912

In Canadian art, about forty years ago the Group of Seven was at its peak. Their painting derived directly from the Canadian scene and landscape, viewed and experienced and painted in terms of the rugged and unspoiled character of this country.

The Canadian landscape is much the same today, but our sense of environment has changed, and with it our values; we no longer think of the northland as remote and inaccessible. Today nearly all parts of Canada are within swift reach by air; the canoe has become largely a pleasure craft, rarely a vital necessity.

The effect of these rapid changes on art in Canada has been to move us into the main stream of international movements in art, so that today the particular spirit of creative adventure that motivated the artists of the Group of Seven and their attitude toward and response to the country which gave their paintings their distinctive character cannot be revived or repeated. We are in a time of transition.

written about 1960

In Memoriam to a Canadian Artist 1950

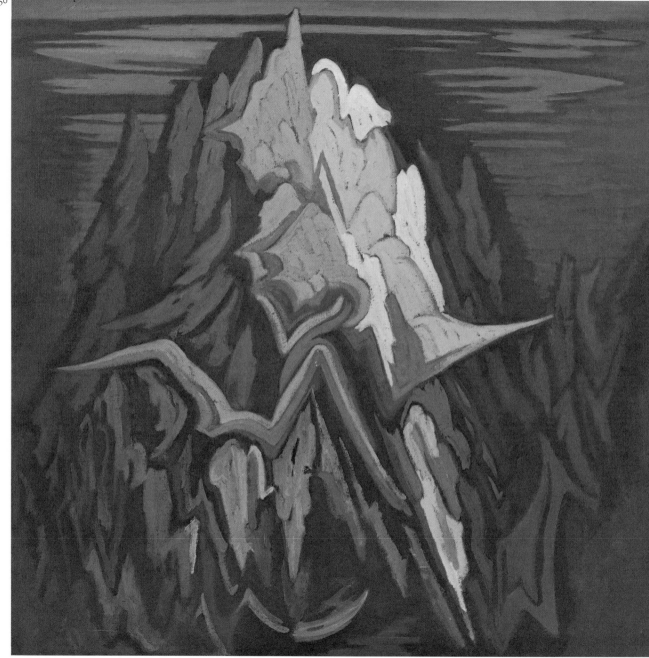

When I laid in the painting, it suddenly struck me that it could express Tom Thomson, and thereafter it was Tom I had in mind – his remoteness, his genius, his reticence.

Living in and wandering the North, and more or less literally copying a great variety of her motives, led to a decorative treatment of her great wealth of material in designs and colour patterns conveying her moods of seasons and places with suggestions of her pervading spirit. It seemed the only way to embody the charm of so many of her motives and the intricacies of her extraordinarily rich patterns.

The artists saw decorative designs everywhere in the the North, and material for every possible form of embellishment for our daily life, and all of it waiting to be used to create a home for the spirit of a new-seeing people.

This decorative phase touches the whole glorious surface display of nature, and creates patterns in the flat, re-expressing her moods.

. . . Dr. MacCallum and I took a train to the Soo, and next morning went up the Algoma Central Railroad and discovered a paradise for the Canadian painters — wild, rugged, tumultuous country. . . . After that each October for four years, in a railroad box-car with a hand-car and a canoe, MacDonald, Jackson, Lismer, and I explored and painted Algoma. . . .

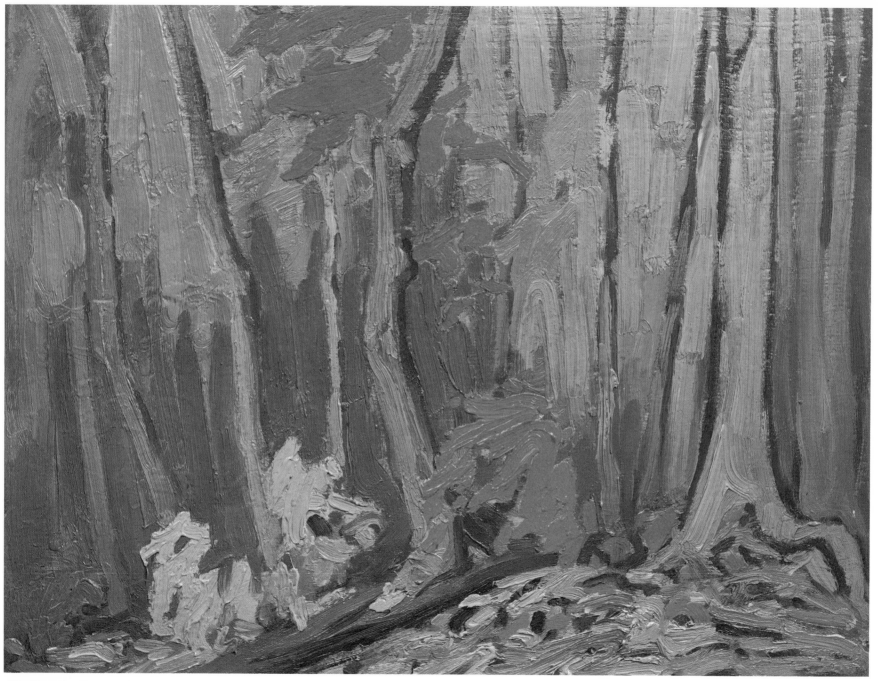

Wood Interior, Algoma 1918

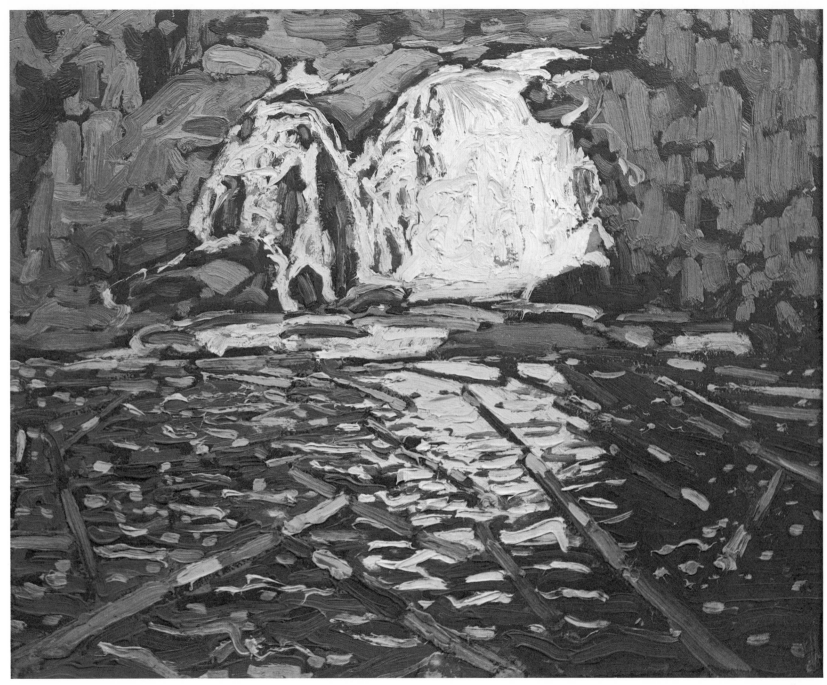

Agawa Falls 1918

48 One can almost guarantee that two months in our North country of direct experience in creative living in art will bring about a very marked change in the attitude of any creative individual.

It will bring him an inner release and freedom to adventure on his own that is well-nigh impossible amid the insistences and superficialities of Europe.

Our aim is to paint the Canadian scene in its own terms. This land is different in its air, moods, and spirit from Europe and the Old Country. It invokes a response which throws aside all preconceived ideas and rule-of-thumb reactions.

It has to be seen, lived with, and painted with complete devotion to its own life and spirit before it yields its secrets.

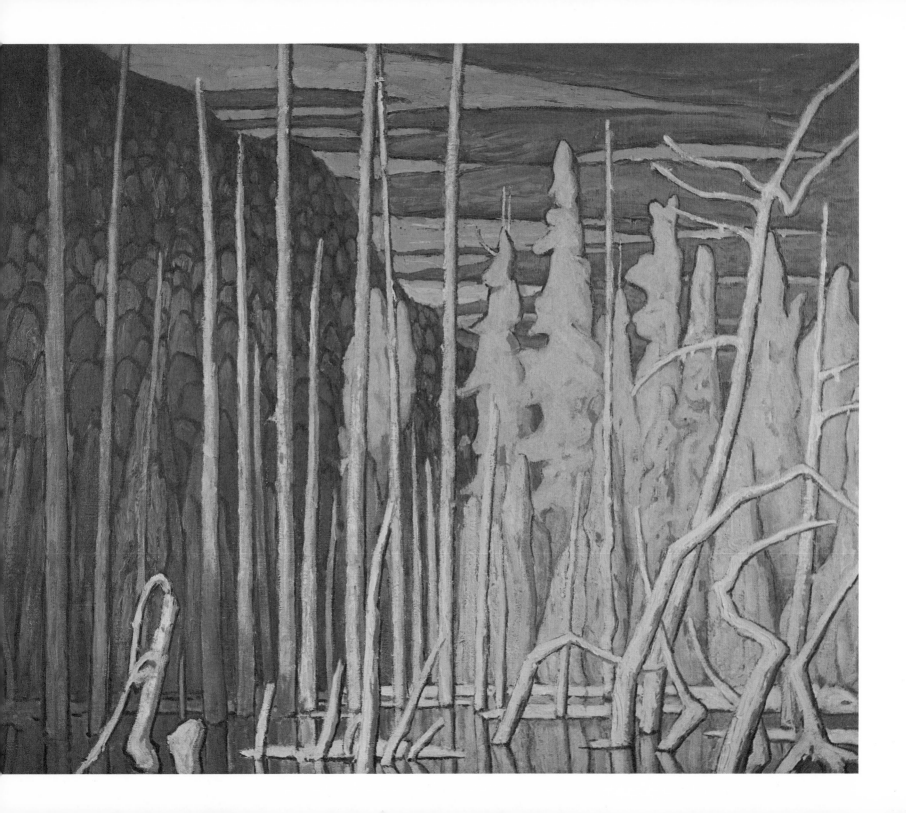

The decorative treatment of the whole glorious surface display of nature, creating patterns in the flat and re-expressing her moods, led to the next phase in which the artists sought to simplify and intensify the mood and spirit of the North, giving forms deeper meanings and their pictures a more convincing sense of living presence.

From the relative prodigality of the decorative phase, they became more vigorously selective, and sought to have no element, no line or colour in the picture that did not contribute to a unified expression.

This led to the utilization of the elements of the North in three dimensions – an organization in depth, giving a still fuller meaning, a still deeper significance to every form and to the relationship of all the forms in the picture.

. . . One year Jackson and I left Algoma and discovered Lake Superior . . .

52

Indeed indeed
The ancient of days
now speaks in light
now speaks in the hosts of light
now speaks in tree limbs and leaves
in silver winds and silver running waters
Now speaks the simple unutterable
So simply, directly timelessly
A moment's egress into eternity
With a clarity
No man has voice for
No man has quiet life enough for
No man is clear enough to receive completely
 and fulfil.

from Contrasts, *1922*

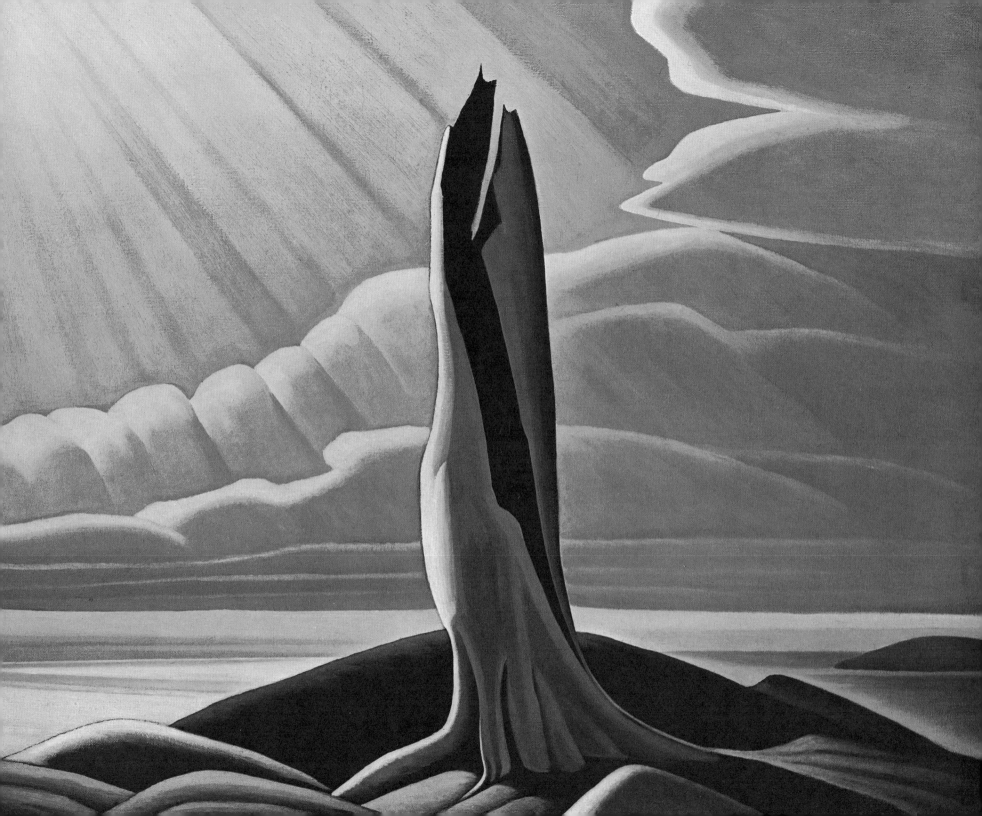

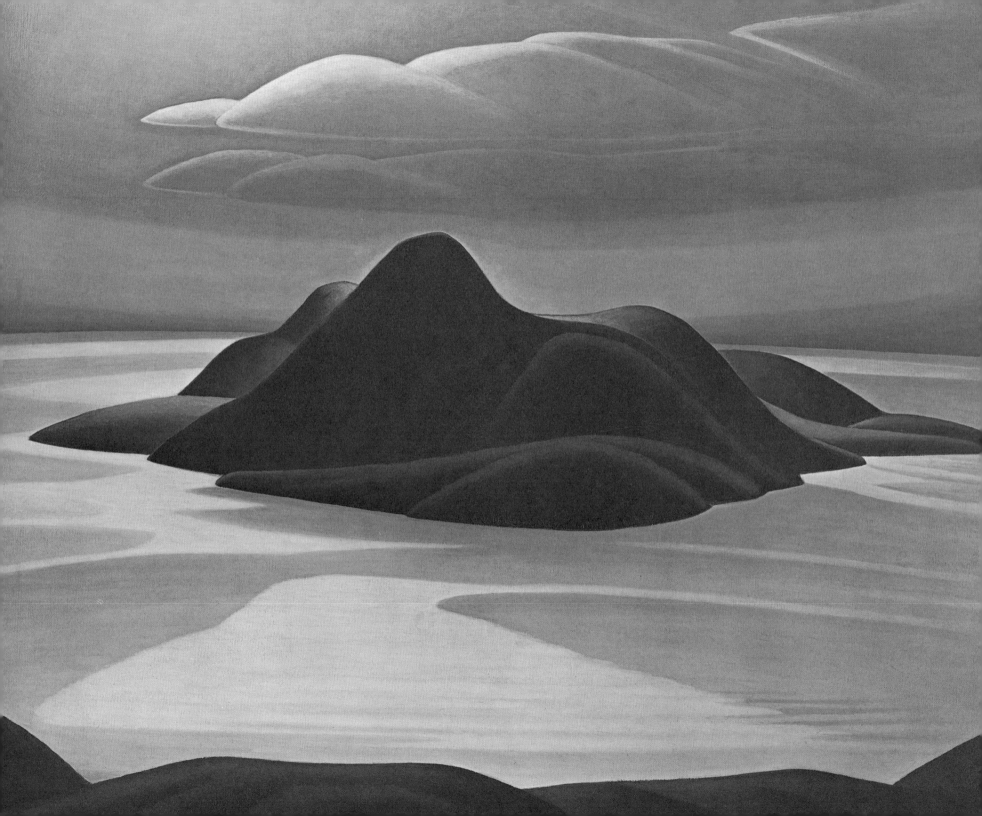

Island, Lake Superior 1924

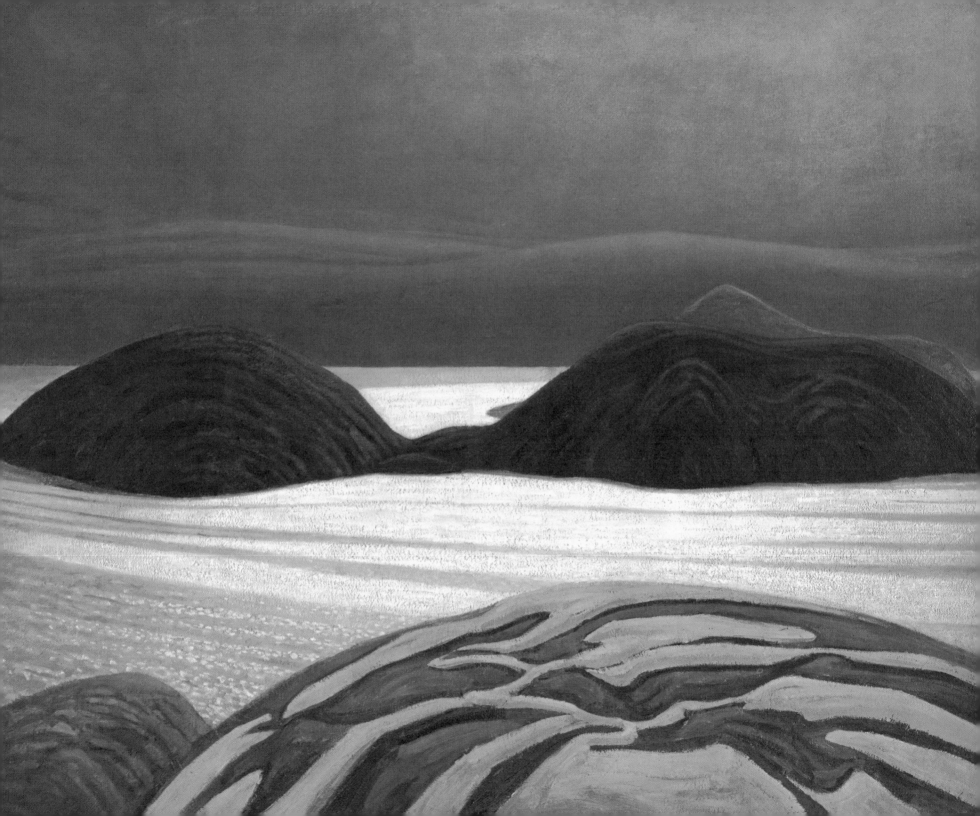

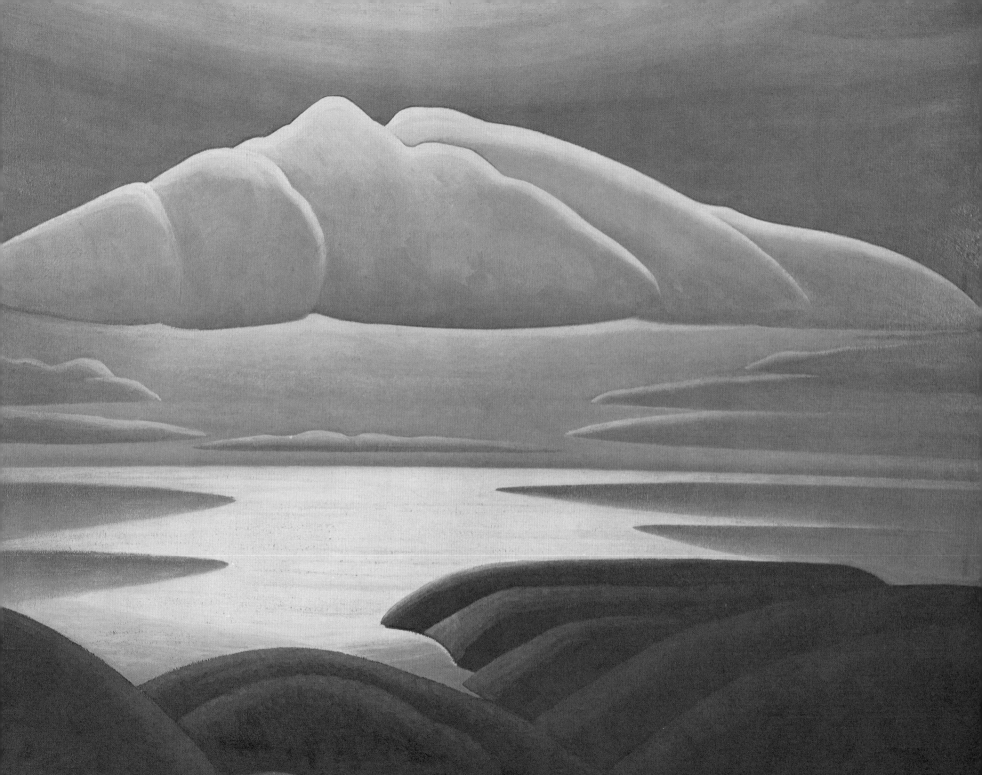

In this later phase – in pictures designed in depth in space – we should be able to live and breathe and experience fully. Our spirits emerge into purer creative work wherein they change the outward aspect of nature, alter colours, intensify forms, purge rhythms of pettiness, and seek to enable the soul to live in the grand way of certain wondrous moments in the North when the outward aspect of nature becomes for a while full luminous to her informing spirit – and man, nature, and spirit are one.

. . . Jackson and I went to the Rockies; walking the country carrying our back-packs, we lived like forest-rangers. . . .

62 . . . I went four years via Ottawa to Lake Louise, Moraine Lake, and Yoho. . . .

When I first saw the mountains, travelled through them, I was most discouraged. Nowhere did they measure up to the advertising folders, or to the conception these had formed in my mind's eye. But, after I became better acquainted with the mountains, camped and tramped and lived among them, I found a power and majesty and a wealth of experience at nature's summit which no travel-folder ever expressed.

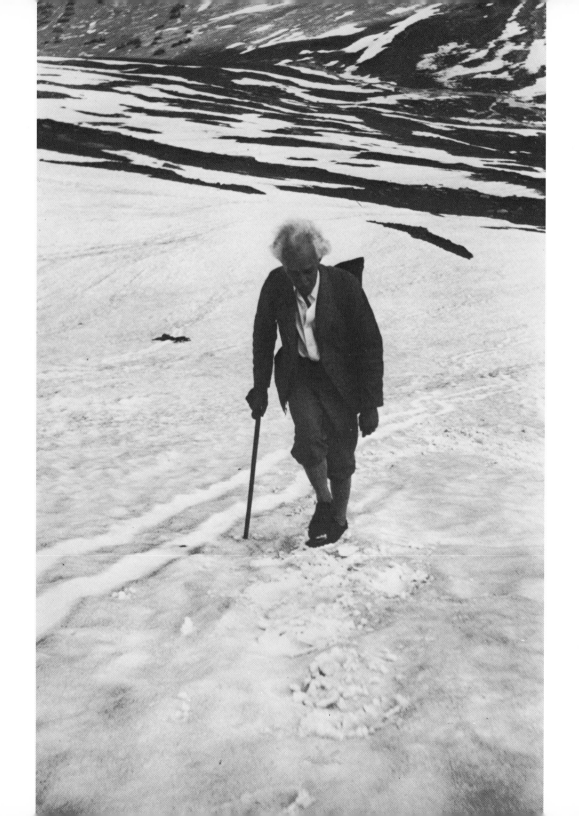

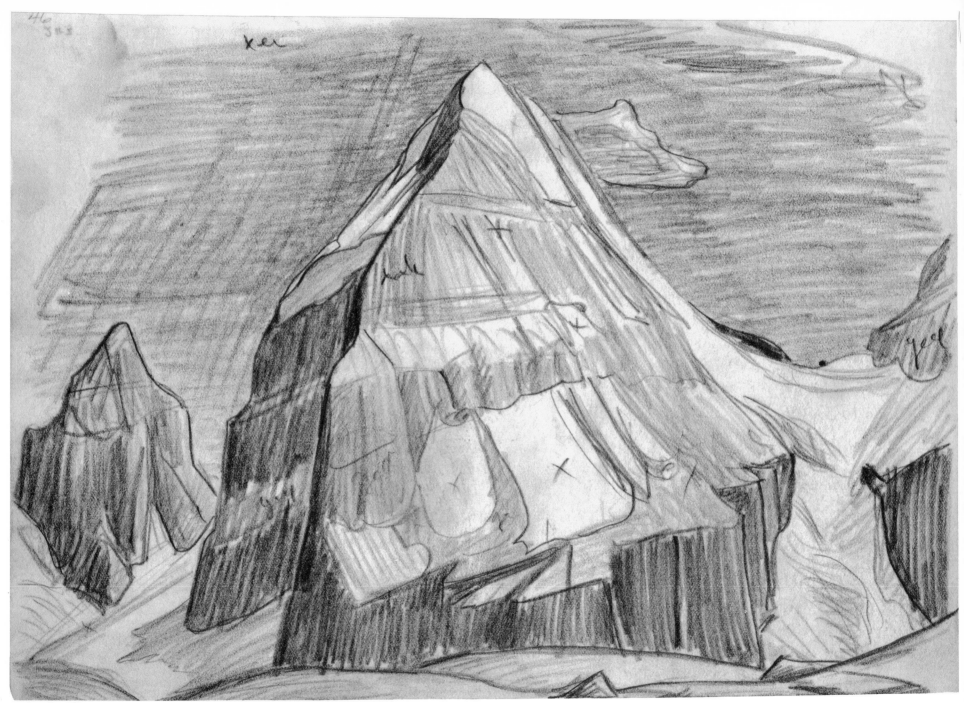

Mt. Lefroy 1927

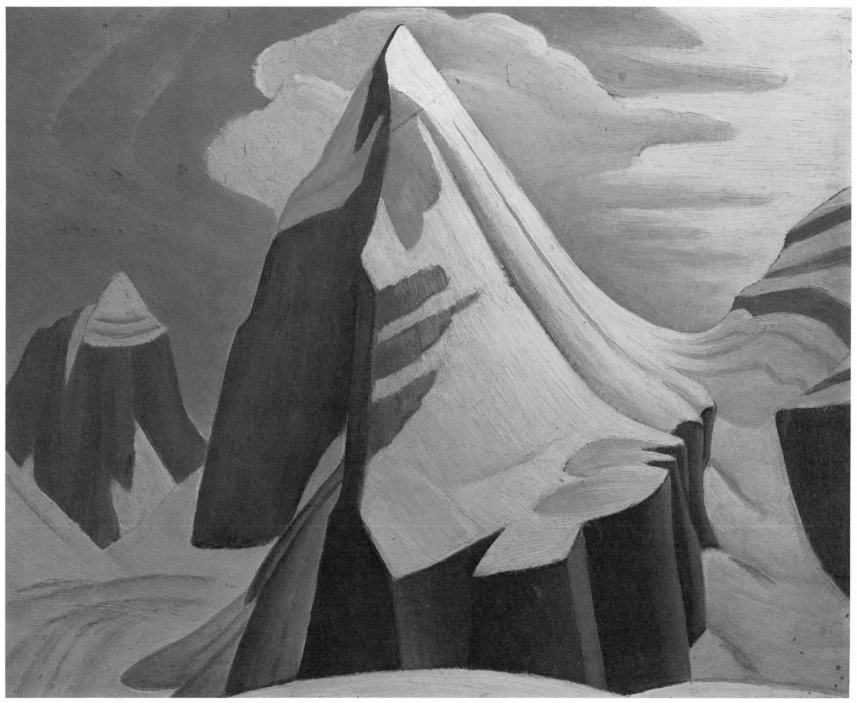

Mt. Lefroy 1927

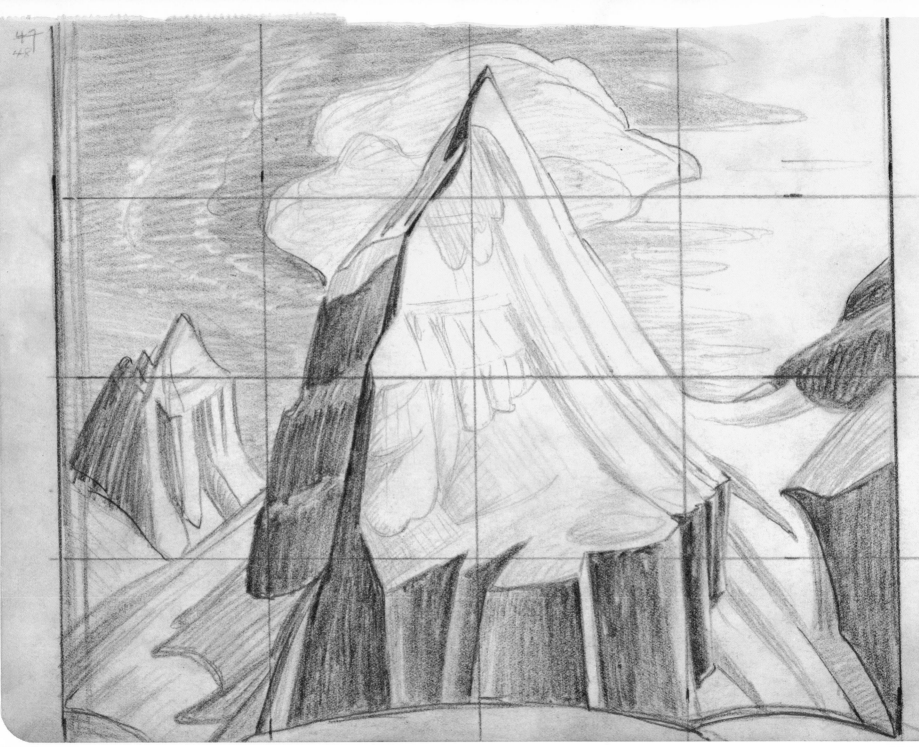

Mt. Lefroy 1930

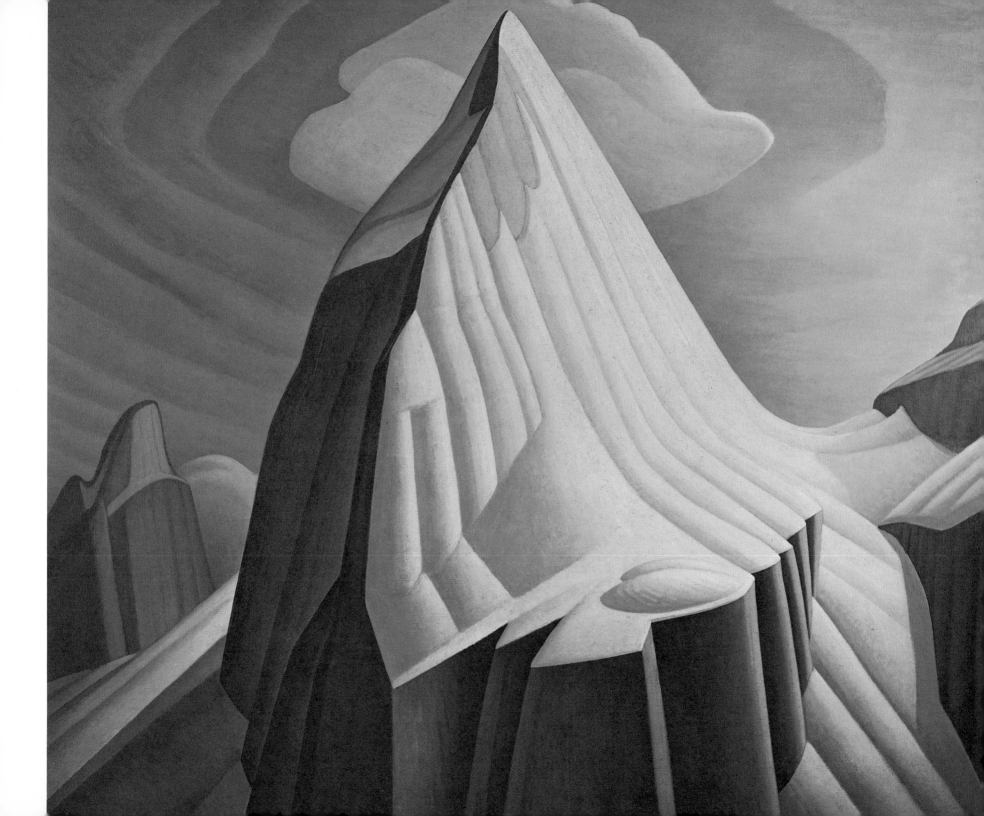

Art unfolds the consciousness, enriches life – not in the plutocratic sense; makes one more alive; widens the horizon; refines the whole vehicle whereas grossness limits the understanding to gross things; widens the sympathies, breaking the hard trivial personal barriers.

Art is a stimulus to perception, thought, awareness. This stimulus comes from the creations of men as well as from nature and other humans.

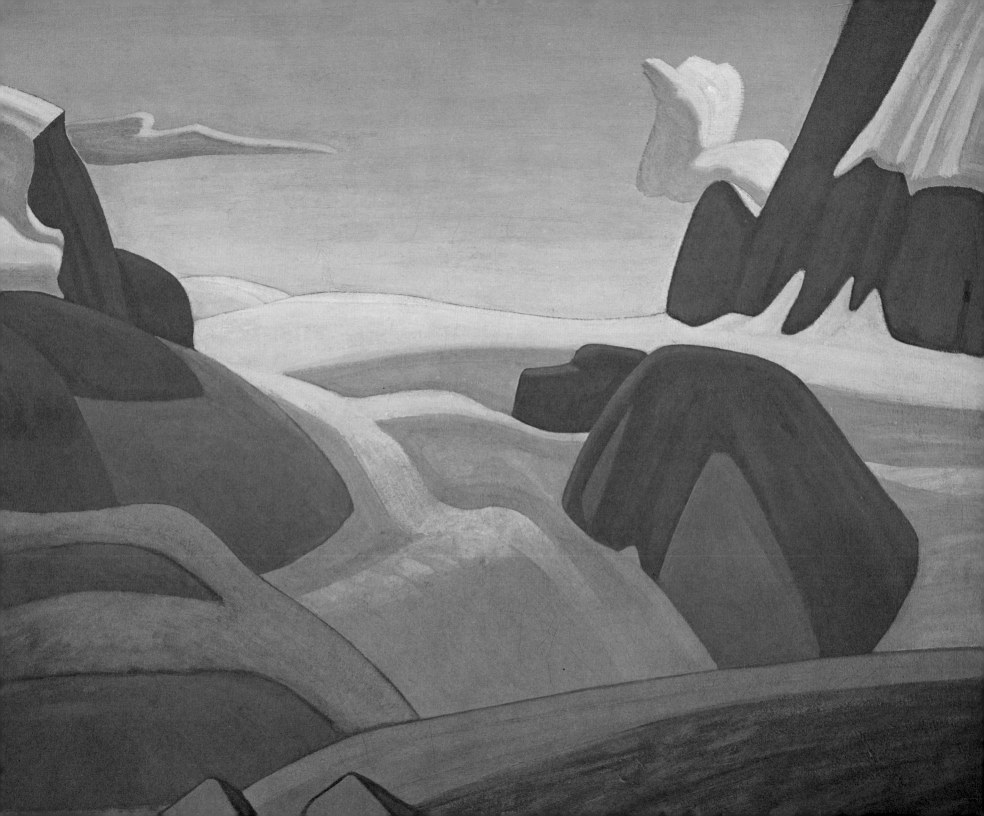

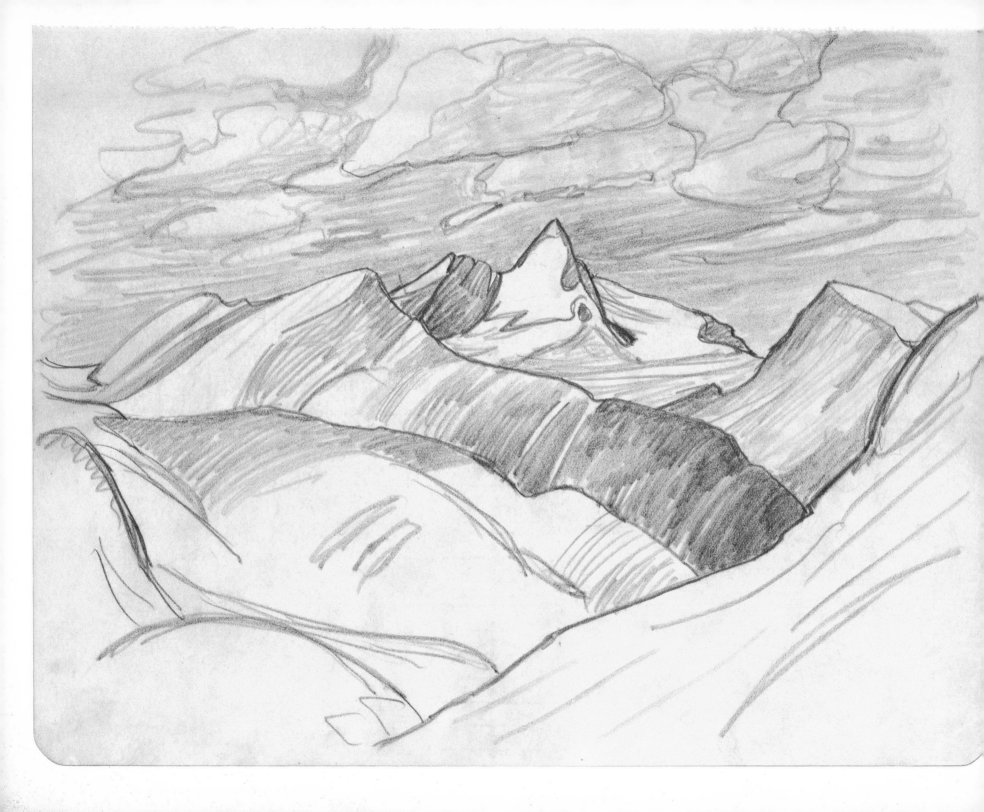

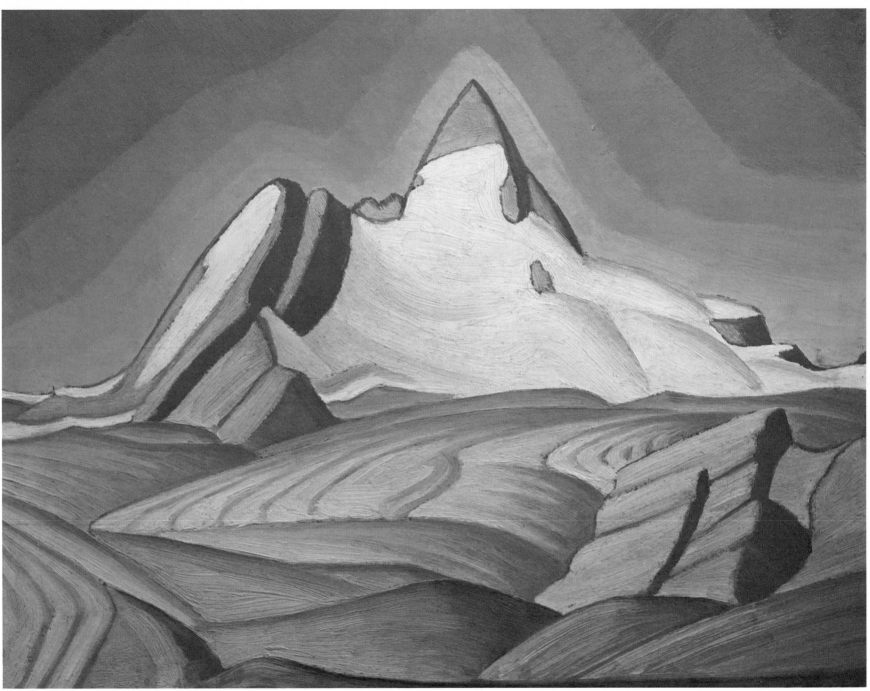

Isolation Peak 1929

Isolation Peak 1929

The creative spirit is austere; it contains its own discipline for men.

There is no sentimentality, no soothing for any complacencies, no pretty comfort.

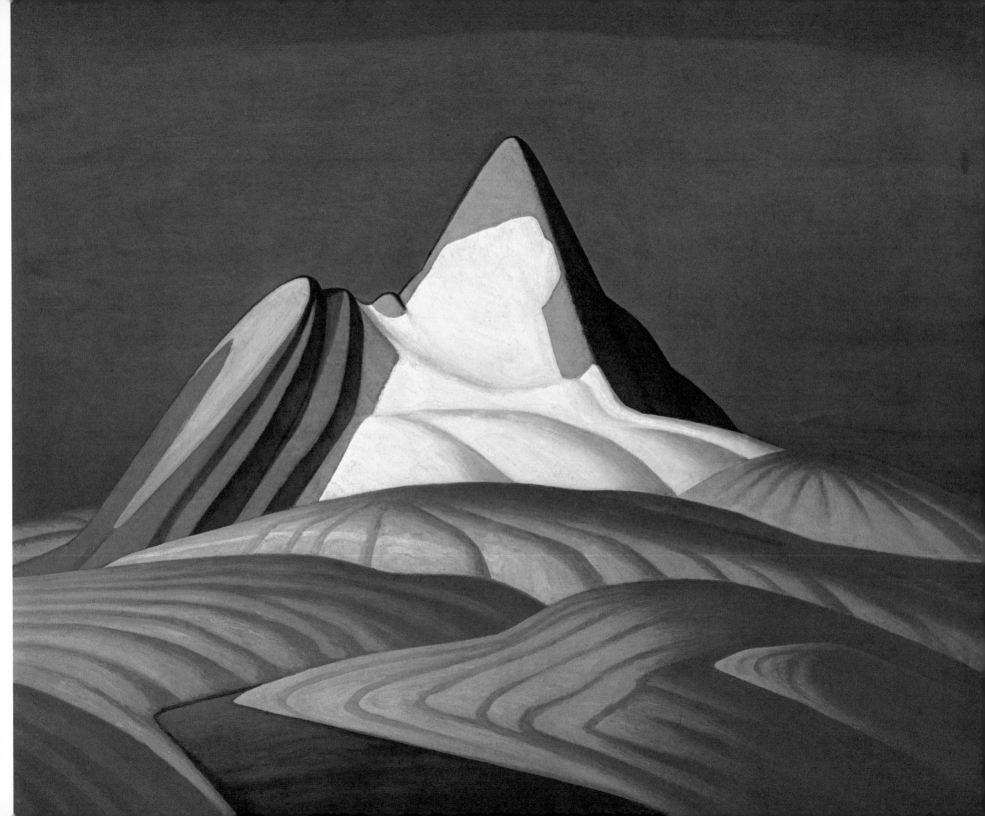

Art cannot be taught. It can be given opportunity and encouragement to grow. It is a partly irrational activity, and depends on a delicate balance of contraries which overstability destroys.

Art cannot be taught; it can only be elicited; it is inherent in each one of us. Indeed, nothing of abiding value can be taught; everything eternal must be elicited.

Vision is the essential of creative endeavour; all else follows.

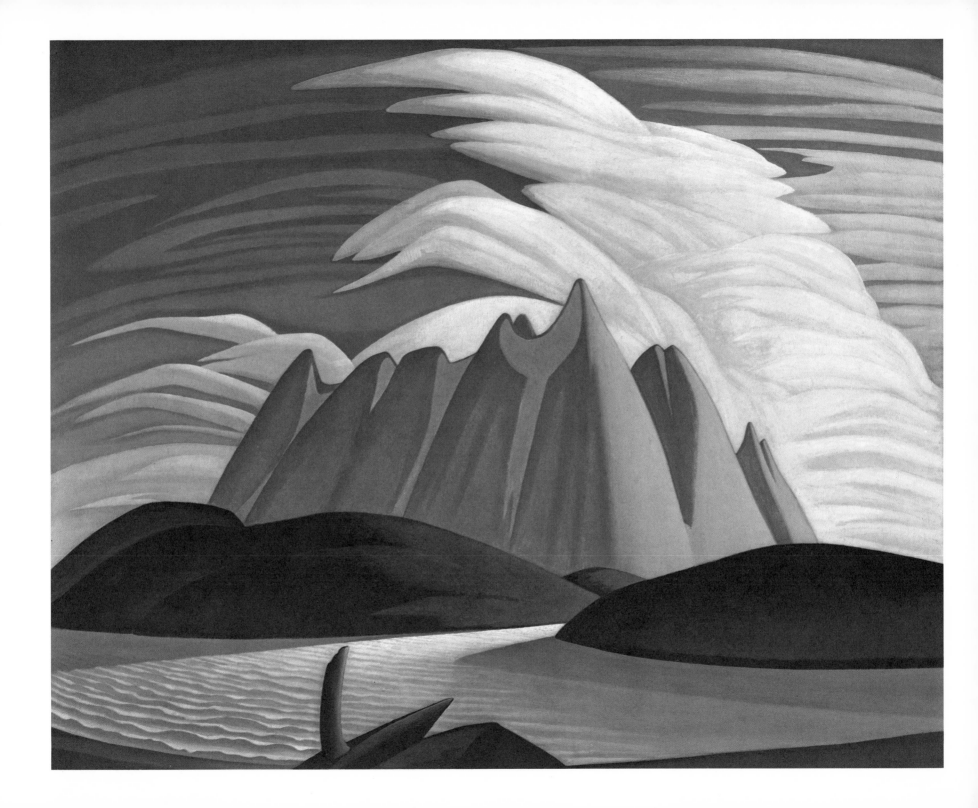

All creative activity in the arts is an interplay of opposites. It is the union of these in a work of art that gives it vitality and meaning.

If we view a great mountain soaring into the sky, it may excite us, evoke an uplifted feeling within us. There is an interplay of something we see outside of us with our inner response.

The artist takes that response and its feelings and shapes it on canvas with paint so that when finished it contains the experience.

. . . Back of Jasper and at Mount Robson we were afraid of grizzlies. . . .

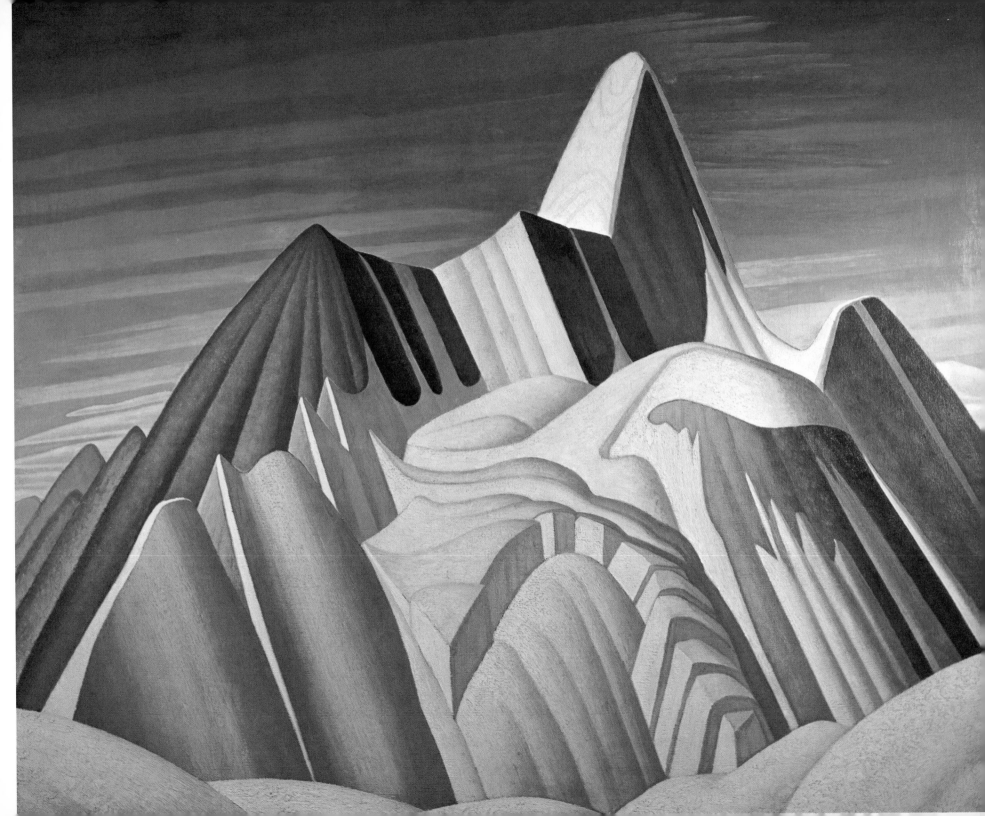

78 A picture can become for us a highway between a particular thing and a universal feeling.

Light House, Father Point 1932

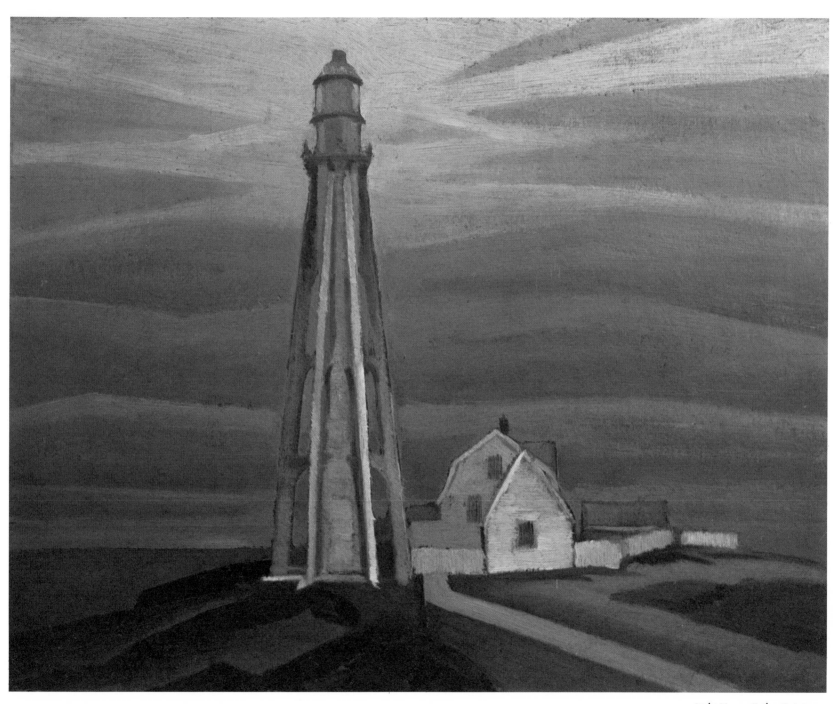

Light House, Father Point 1932

Light House, Father Point 1932
The National Gallery of Canada, gift of the artist

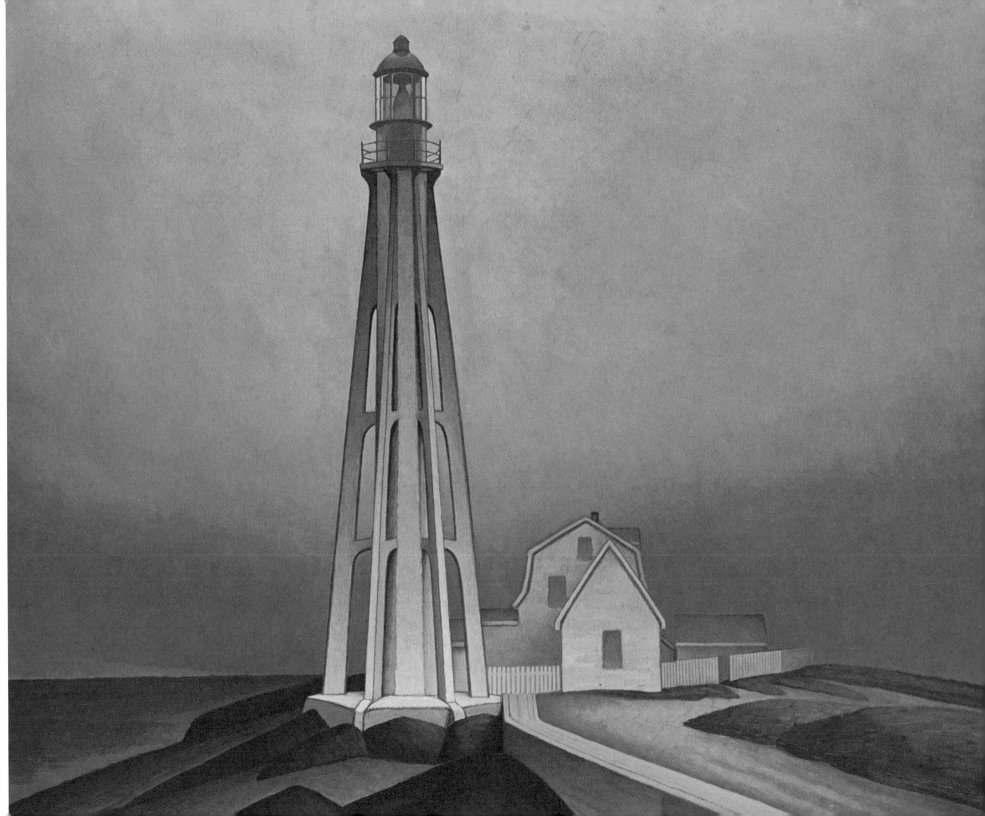

82 The first requisite in understanding art is to view it in terms of direct, immediate experience. That is the creative way, a way that fits the terms of the artist's procedure and life. To bring to art any arbitrary standard — the archeological method, the historical method, the criterion of a style or a tradition — while it may have intellectual value after the genuine experience of its inherent life, is more or less to miss its real meaning.

Icebergs, Davis Strait

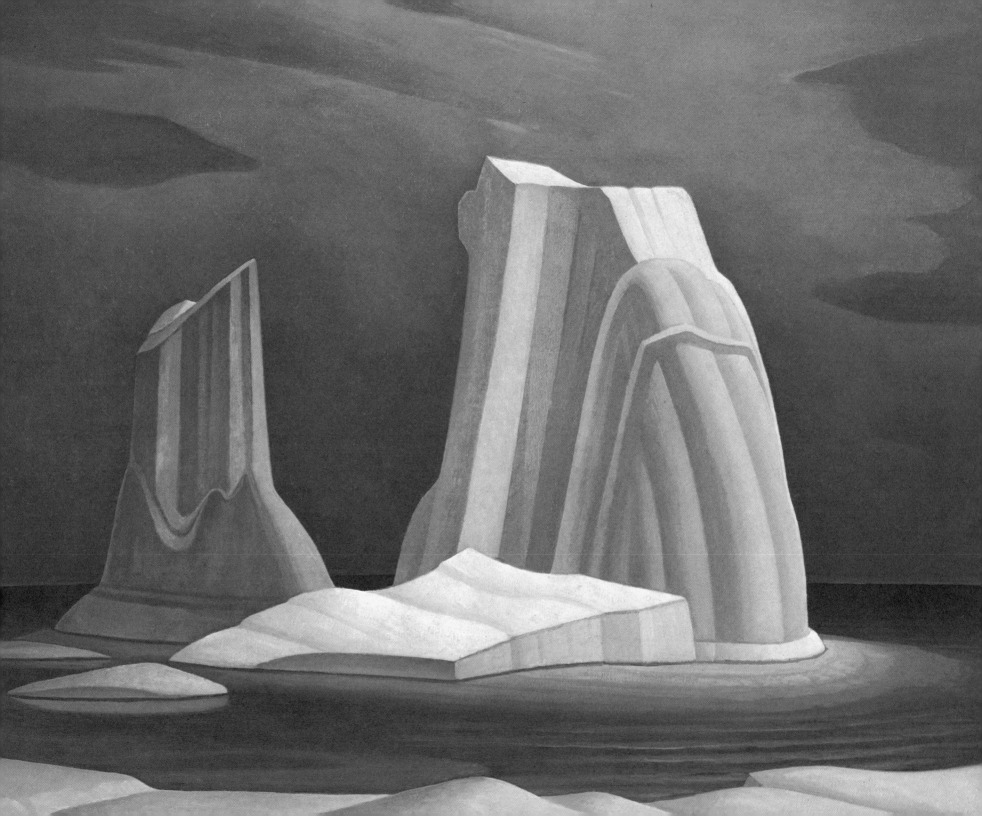

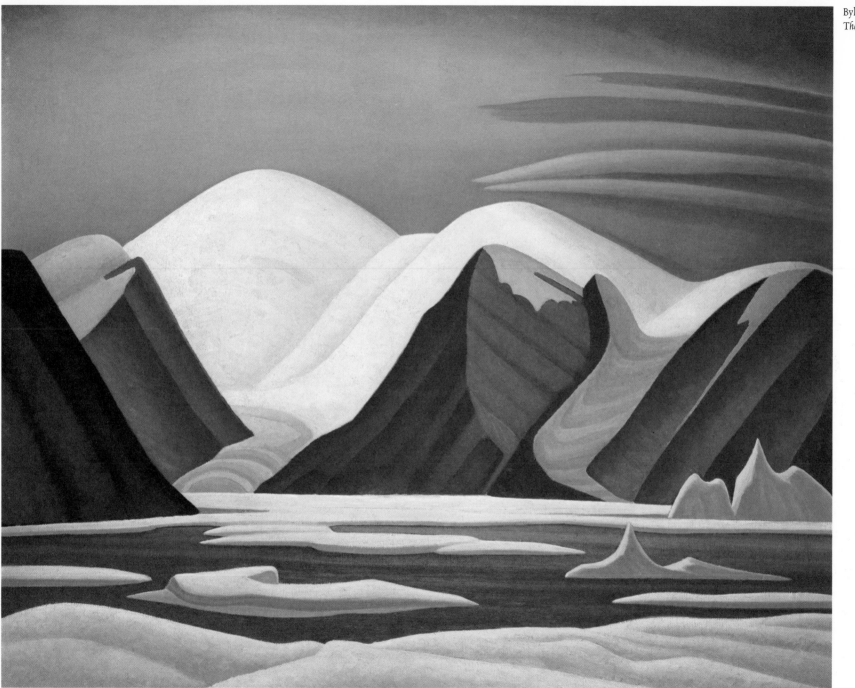

Icebergs and Mountains

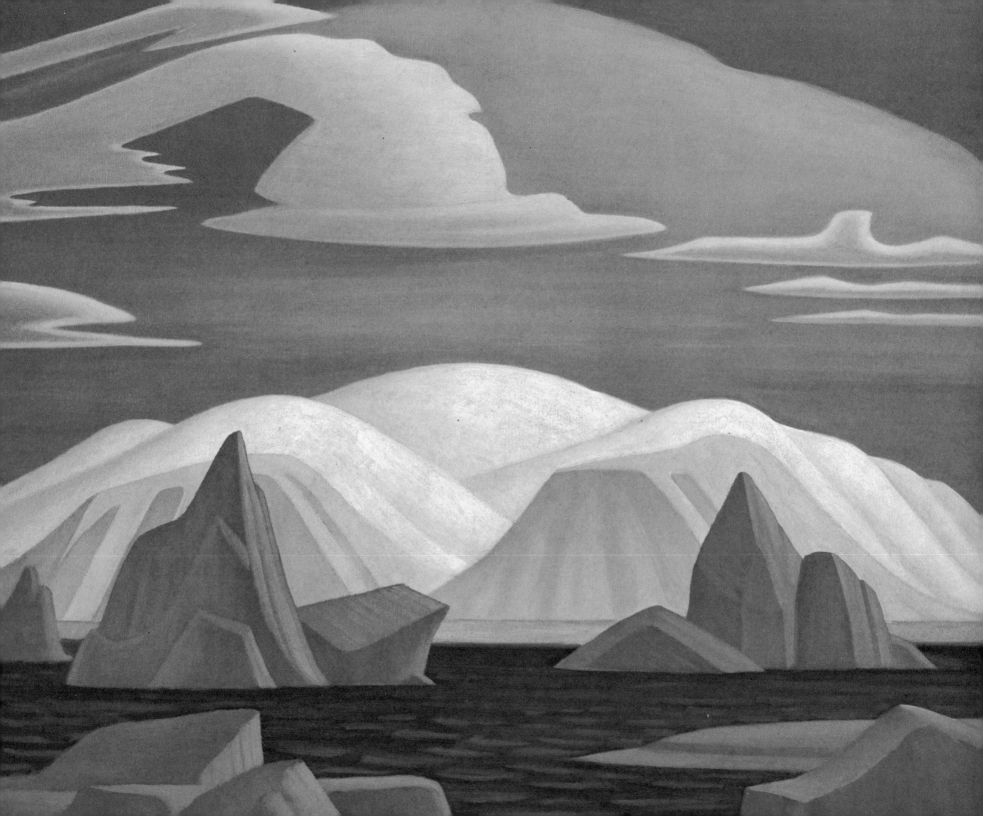

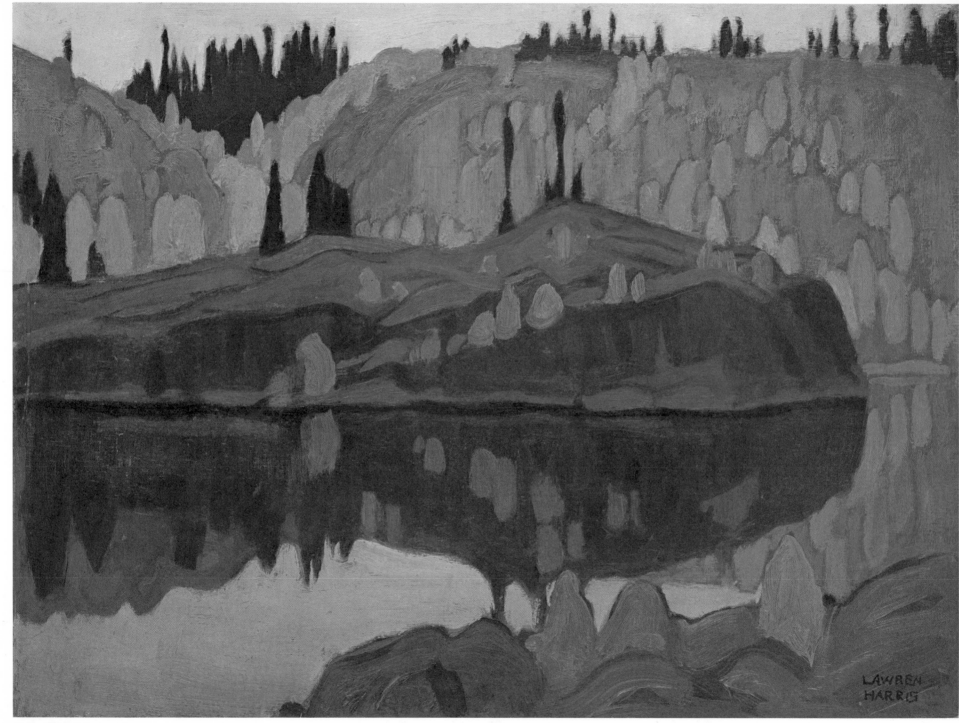

Coldwell Bay, Lake Superior 1925

Through these four phases: copying nature, the decorative treatment, organization in depth, and purer creative work in changing the outward aspect of nature – through these four phases the artist has learned mastery of outward fact; he has become in some degree master of moods; and he seeks to become one with ever purer means of expression. Thus he is led to the abstract, universal qualities that give a work a suggestion of eternal meaning, make of it a universal experience.

But the whole evolution from outward aspect to the one indwelling spirit has been a steady, slow, and natural unfolding through much work, much inner eliciting experience and contemplation.

We need to know what art is and what it is not — what is its particular realm.

Art is not knowledge — though knowledge certainly enters into its creation at nearly every turn.

Because art is not primarily knowledge — the living heart of it cannot be explained.

It is evoked, elicited, stirred into being by participation in its life.

In one sense art is an organizing principle which confers meaning, shape, and sometimes immortality on the perishable materials of human experience and character.

In another sense it is experience through *heightened* sensibility.

This experience is controlled and clarified and made communicative by the organizing principle — which plays such a large part in the actual creative process of making works of art.

Art is emotive — that is, it has to do with emotional and intuitional values, with awareness, perception — precision, keenness, and depth of feeling — and to understand it we must in a sense become part of it, share in it, be moved, be stirred — have our sensibility awakened and sharpened.

For it is through the awakening and development of our sensibility, our awareness of proportion, rightness, and appropriateness that we alter our values in life,

become creative each one within himself or herself.

For science a sign, a symbol, is valid only if it is emotionally neutral. Scientific signs simply direct the mind to some fact or element.

Such signs are plus and minus, algebraic symbols, chemical formulas; they are addressed to the intellect, *not* to the emotions.

In art, however, all elements of expression — such as lines, colours, values, gradations, relationships, and form — must have emotional value.

Nothing in a work of art should be emotionally neutral.

Everything in a work of art is there to create an emotive, intuitional, or spiritual structure — idea, image, or living form.

Someone has said that science is a 'logical equation of the world', and we might say that art is an emotional and rhythmic equation of the world.

They complement one another.

Knowledge is one great necessity.

A developed and controlled sensibility another great necessity.

In the higher reaches of what we call the intuition, however, art and science meet.

For though their approaches are different, the creative scientist and the creative artist both function — in their best moments — on the plane of intuition.

Now there is an immense amount of knowledge about art – all kinds of books on art.

But this knowledge about art is not art – and may take us farther away from art – as living, vibrating, resonant experience – than if we had not bothered with it at all.

We may, for instance – to turn to music – read about Beethoven and his music – read an analysis of his 5th symphony. But the symphony will not mean anything living and vital to us until we not only hear it but experience it – until we respond to it, participate in it, are stirred to the depths of our soul by it – then we are inwardly moved – note the word – into a living realm of power and beauty and nobility that far transcends our ordinary workaday life.

We are for that short space of time a changed man or woman.

from 'The ABC of Abstract Painting'

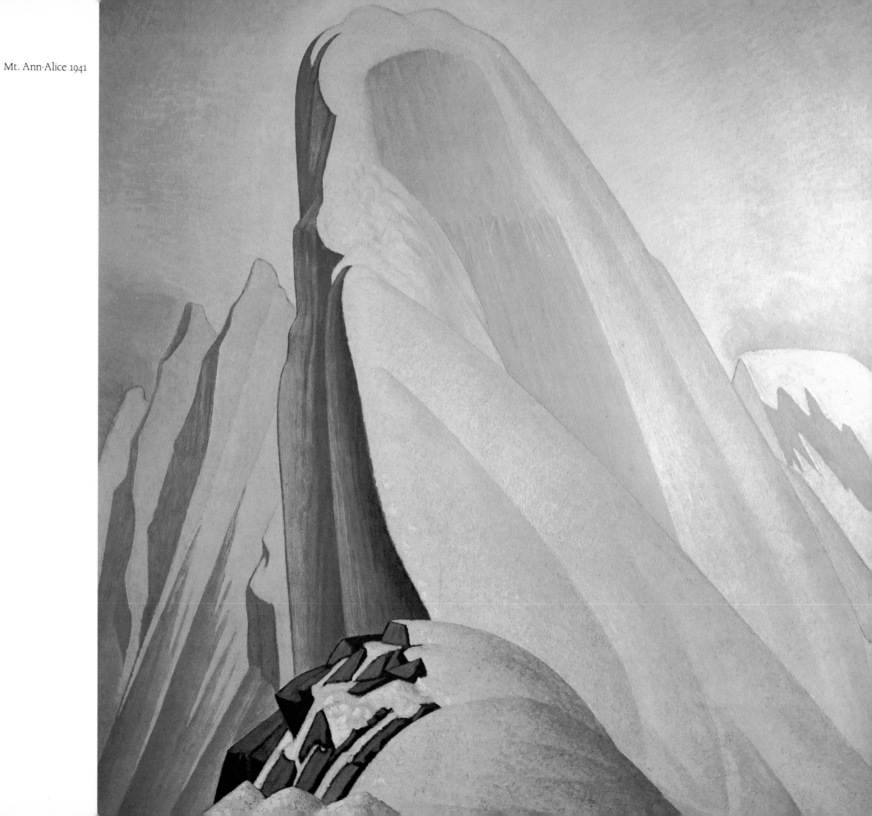

Mt. Ann-Alice 1941

My purpose in attempting to paint abstractions is that there is at once more imaginative scope and a more exacting discipline in non-objective painting. I have had ideas insistently forming which could not be expressed in representational terms.

Where the older representational artists would paint a number of sketches and paintings of subjects seen on a trip in the mountains, an artist today painting in the abstract expressionist manner would in one painting endeavour to achieve a combination of moods, rhythms, character, and spirit that would be an expressive synthesis of many mountain experiences. The result, if successful, would be an extension of experience beyond the range of realistic painting.

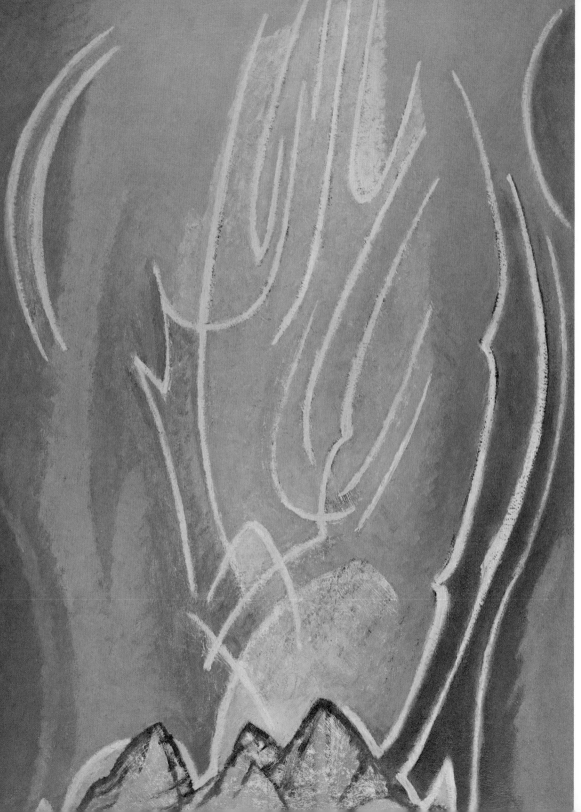

Mountain Spirit 1945

Mountain Experience 1954

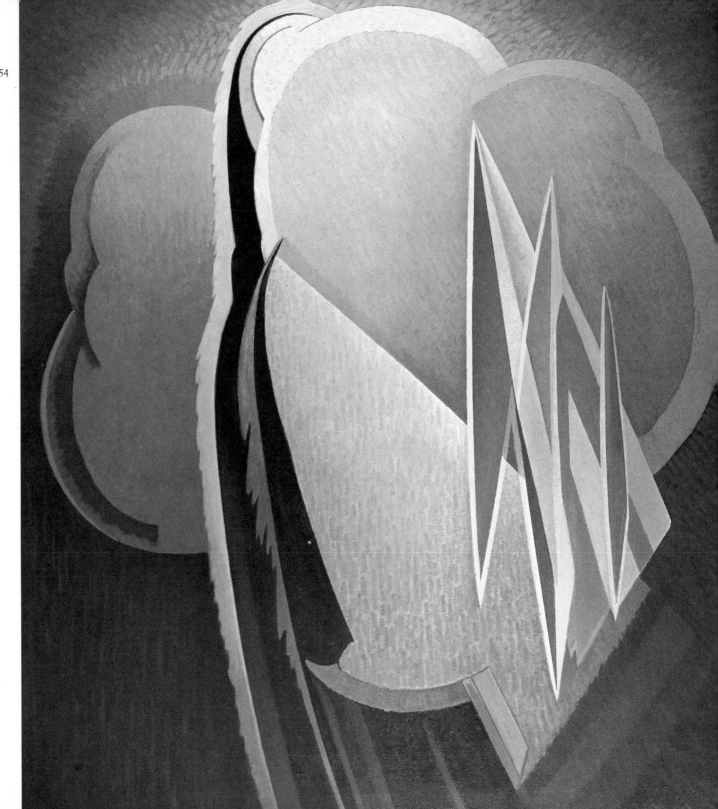

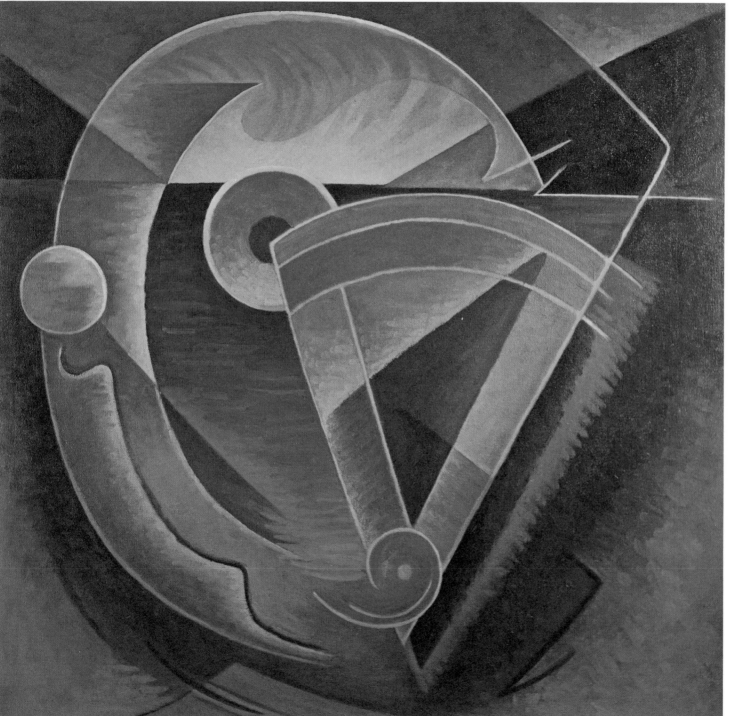

From the Harbour to the Open Sea 1952

Migratory Flight 1950

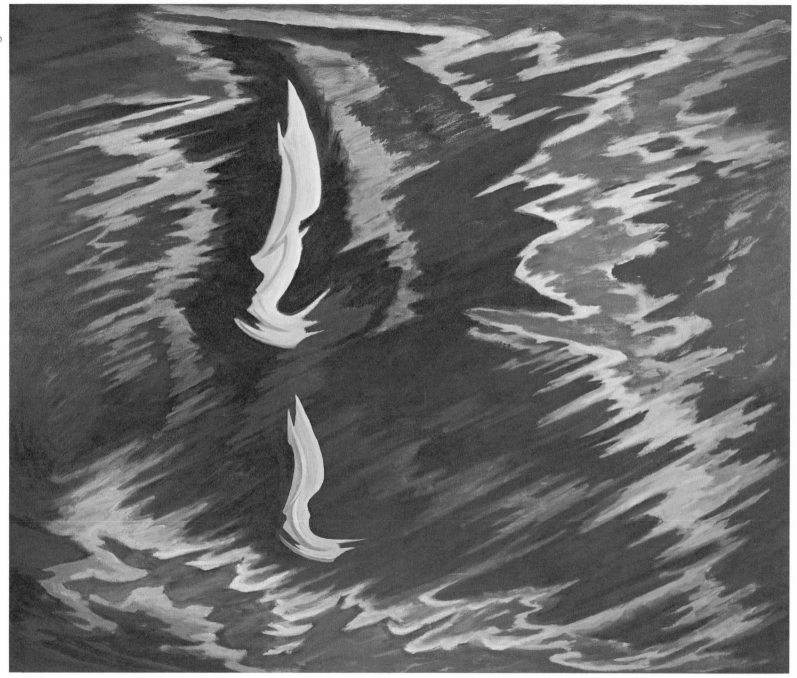

The modern artist, instead of having symbols represent things we know — symbols we are familiar with — makes them into a new *experience*.

Our people who pay attention to the development of our art view transitions from one phase to a deeper phase sometimes with misgivings.

There is always something given up in every change, and this means perhaps a little regret.

Each new phase constitutes a new experience, a fresh revaluation, readjustment, and alteration of emotional values that at times may prove trying.

But the growth has been an inevitable and natural one, and will broaden and extend and deepen in the future.

Inevitably, if the artist doesn't slip into the deadening backwater of desire for reward or position, he is led from particular expression and outward aspect toward universal expression and the spirit that informs all life.

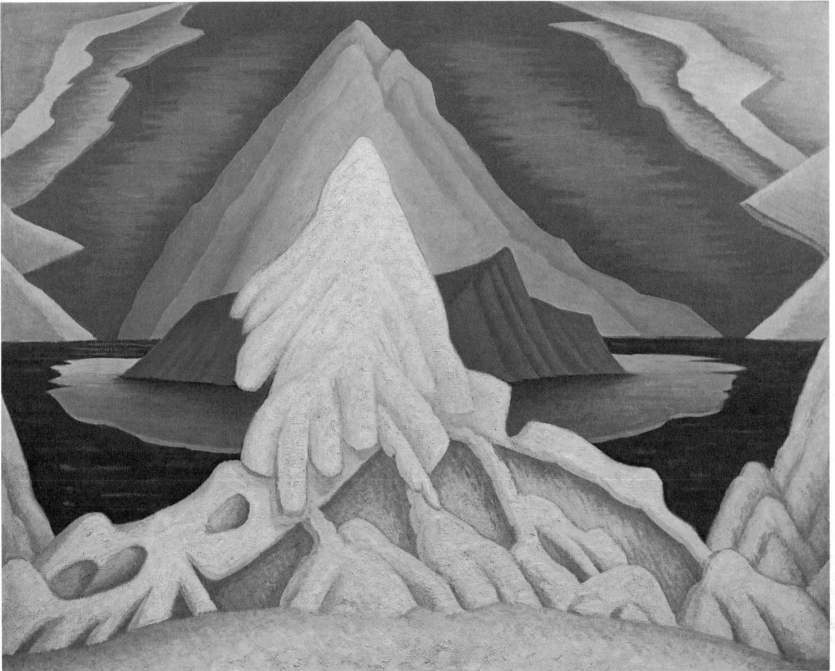

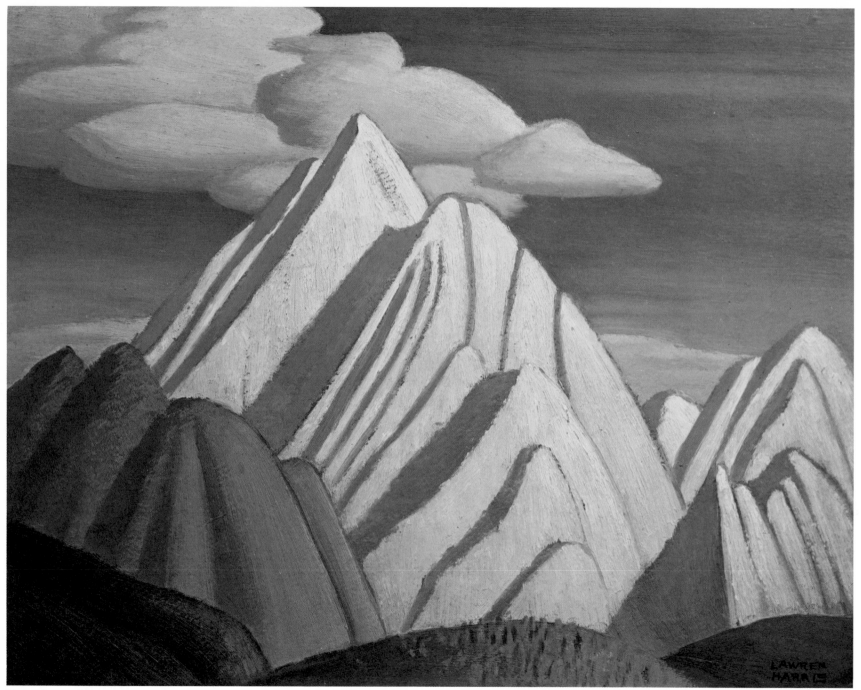

Mountains near Jasper 1926

Science - objective | 2 great realms of life
art - subjective | all experience of man is
 included in these 2
proofs knowledge
facts Science - uses words & symbols such
 mathematical & chemical symbols &
 formulae

moods- art only means of communication
feelings- we have in those matters that lie beyond
emotions - language — all subjective.
experience
 - feeling, emotion, understanding are
 entirely object subjective.

language art
 every shape, colour, every
relationship of shapes
& colours line & volume
has meaning, significance
into but not a
meaning which can be
put into words.
 the same with
 music

in deepest feeling we
are silent — struck
dumb as some say
now this is very sig.

there is for all this only
the language of art or
the different languages of the
diff. arts.

12

When it was suggested that I say a few words on 'Symbolism in Art', I thought I would take the liberty of changing the subject to 'Symbolism and Art', because at their separate poles, symbolism and art are two different manifestations of the spirit in Man.

Symbolism and Art have different values and different functions. Yet, there is an art of symbolism and there is symbolism in certain forms of Art. There is also a phase of art wherein they fuse and interpenetrate and unite to the enhancement of the particular type of art suited to and created by this fusion.

The purpose of Symbolism is primarily to instruct, to point the way or a way – to such an extent that we can speak of the language of symbols, for instance in science and music and mathematics. Religious symbols are also definite – the halo signifies saintliness, holiness; the cross, sacrifice, sacredness. There are national symbols: the Swastika, the Hammer and Sickle, the British Lion, our own Beaver; and there are flags. In some Eastern teachings the symbols contain the whole of the philosophy; there is the square, and the triangle with the apex pointing upwards – the four lower principles and the triad of divine principles together symbolizing the sevenfold man, the microcosm, and the sevenfold cosmos, the macrocosm.

Symbols thus represent something definite; they are intellectual counters, and form a language that is primarily scientific, and meant to be precise and unmistakable; they always point to some quality or idea in man or the universe or in nature that is not actually in the symbol.

Now, the contrary is true of a work of art.

A real work of art has a definite life of its own – embodies a definite experience. It does not refer to anything outside itself; it does not refer us to an idea or quality as symbolism does – it must embody that quality, be that idea – if it is a work of art. That means that if it is a work of art it is autonomous, self-dependent, has a life of its own, its own organization as a living thing.

Thus, generally speaking, if there be introduced into a work of art a symbol which refers to something outside it, then that symbol tends to destroy or vitiate the unique experience which that work of art embodies. Hence, artists feel more or less ill at ease when they see symbolism in art. They feel that the work should embody the very life the symbol points to, and thus have no need of the assistance of symbols.

For example, medieval artists used the halo as a symbol of saintliness, but also as a shape in their compositions – a shape adding to the beauty, to the aesthetic power of the whole work. That is, the symbol became an integral part of the whole work, though it remained

subordinate to the work as a whole. Such works are examples of the fusion of symbolism into art. Today, the modern artist, in seeking to express saintliness, would not use symbols such as the halo, but would endeavour to embody the very experience of saintliness into his work – so that we, the onlookers, would not see a halo and say, 'That is a saint,' nor would we say, 'How beautifully those halos fit the composition, and what a lovely rhythm in the whole they make.' We would be made, rather, to experience within ourselves a touch of saintliness. This is best illustrated in music, which cannot use symbols but only sounds and an infinity of relationships of sounds. The Beethoven 'Eroica' symphony is a noble and grand work. It does not refer to or describe nobility and grandeur; it *is* noble and grand within itself – in its very substance, the very flow of its sound.

In Symbolism, one may ask 'What does it mean?'; but in Art, one should ask 'What experience does it contain?' Symbolism offers us a key to the meaning and purpose of life; art offers us awareness of spiritual levels in terms of participation and sharing – 'The morning stars sang together.'

from 'Symbolism in Art'

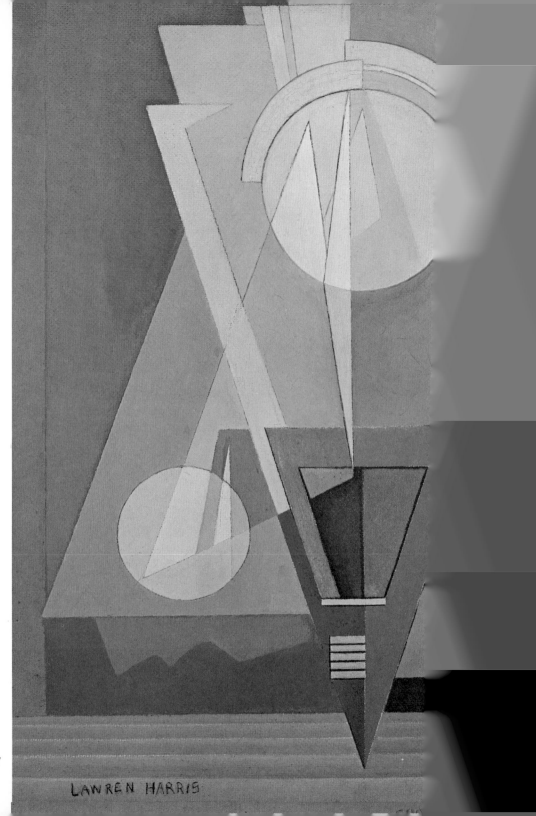

Abstraction 1937

LAWREN HARRIS

102 Mind alone remains stable, and watches the chaos of phenomena, and knows that there is a plastic unity of existence – a changeless harmony – behind the everchanging.

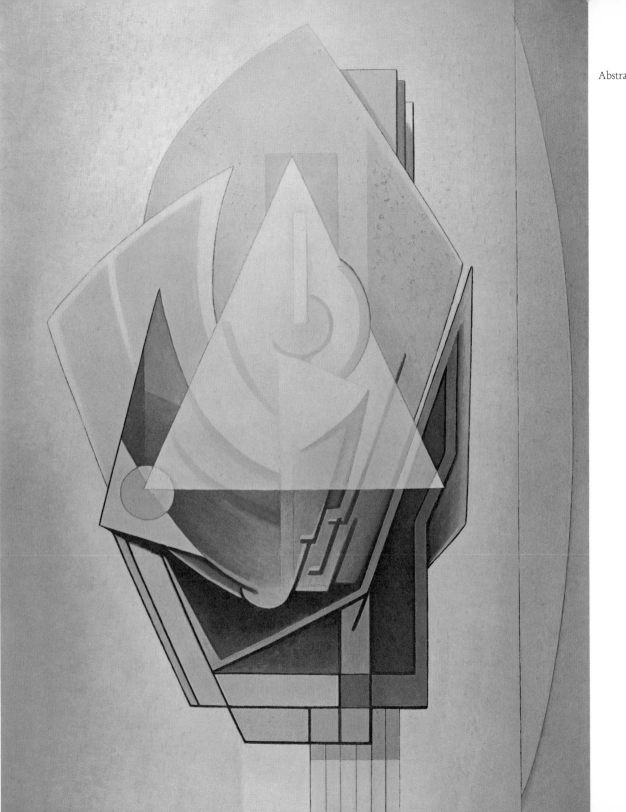

Abstraction 1945

When we realize that every experience comes to us under the universal great law of justice, whether the experience be good or bad, painful or sorrowful, pleasing or otherwise, and that these experiences are but the warp and woof of the pattern of our lives, we will weave with more skilful fingers the design upon which we wish to build.

The reason I do not use titles for abstract paintings is that it is impossible to get their meaning into words. A title, therefore, is likely to interfere with the onlooker's direct response.

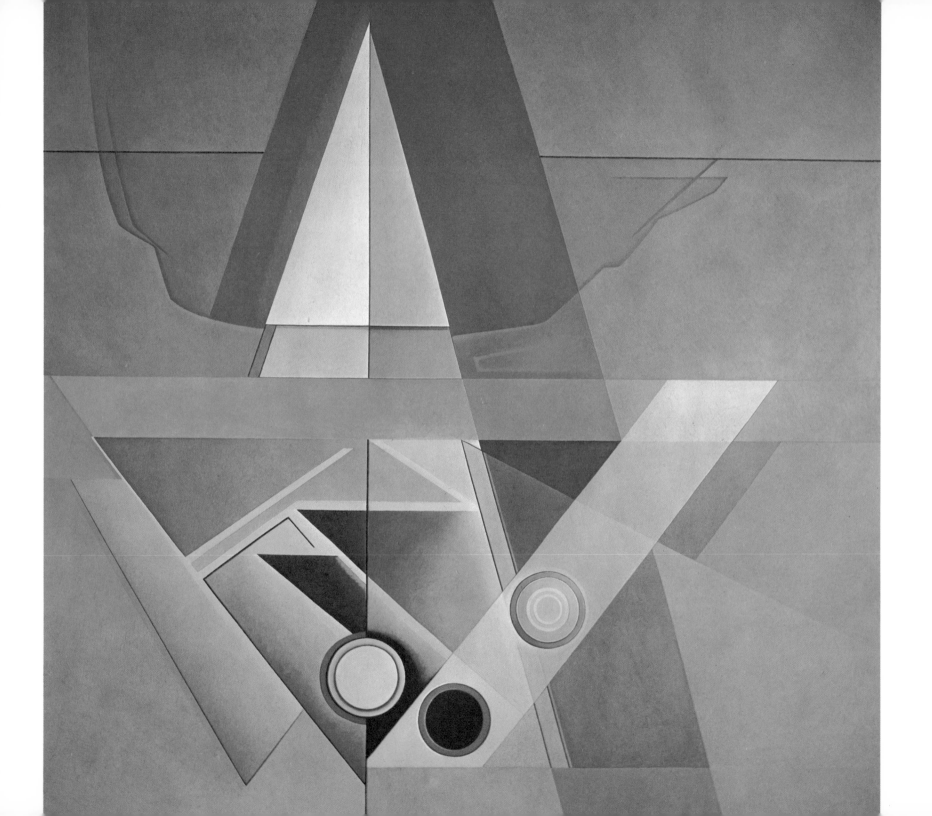

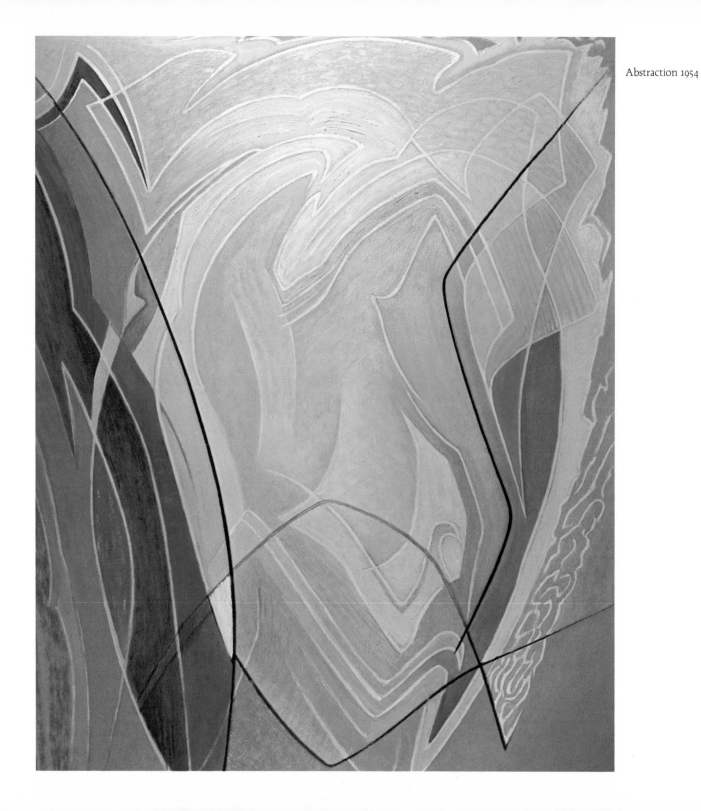

Abstraction 1954

The Fire

The altar in the Heart is pure Love
The fuel that keeps its fire alight, bright and burning
Is personal desire
For aggrandizement, notoriety, fame, acclaim, attention.
For it to burn
 and illumine man
It must be fed with every impulse, every thought and
 mood that arises in the little self or has arisen
 in the long past
This is the essential fire of life
The purification of the long past
 and the tempering of character to consciousness
This is the sacrifice and the escape.

from Contrasts, 1922

Art is a realm of life between our mundane world and the world of the spirit, between the infinite diversity of manifested life and the unity or harmony of spirit, or between the temporal world and the realm of enduring and incorruptible ideation.

It has been said that our highest ideals, our most moving intimations are but reflections of the enduring Laws of the realm of the spirit. Art reflects those laws.

Art at its highest is a non-sectarian search for the life of spiritual values – an adventure toward an illusive yet insistent reality.

Art is one of the ways in which man endeavours to find himself in the universe – to place himself in harmony with the Laws and motivating spirit of the life that functions through those Laws.

Art is a realm of experiences that cannot be defined by words or be pigeon-holed by statisticians or even be embodied in any specific philosophy.

Art contains experiences that cannot be possessed, dominated, or exclusively owned; nor can they be fashioned into dogmas, for that would squeeze out their essential life.

Art, in its highest reaches, embodies or partially embodies the experience of the search for enduring values.

Art has as its function to embody the great range of experiences that exist for us between earth-life and the

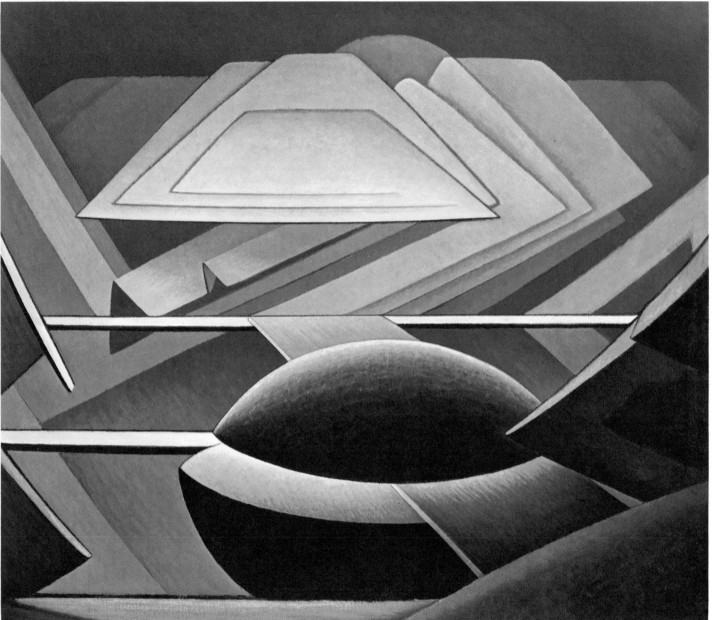

enduring life of spirit that at once informs our life and yet transcends it. This is a statement of Faith, not susceptible to proof. Here are some intimations of its truth:

1. Like the universe, art exhibits order; embodies law; expresses justice; in speaking of art we refer to these essentials as rightness, proportion, appropriateness, a just relationship of parts, a diversity in unity.

2. Like the universe, every work of art is at once a functioning mechanism of diverse factors in unity and a spirit that informs the whole and gives life and meaning to it; an organism – a body containing and expressing an inner life; the structure and relationship of its parts are analysable, but the spirit is intangible and can only be participated in, or experienced. So we cannot discover the spirit of a work of art by dissecting it, any more than an anatomist can find life or consciousness by dissecting the body.

3. The universe is motivated by a power which seems to exhibit intelligence – there seems to be a universal mind inherent in the Laws and orderly processes; a work of art embodies intelligence in all its processes just as it embodies an informing spirit. This intelligence manifests itself as the fashioning faculty, the active creative principle in work – that power which creates the form appropriate to its perception and expressive of *its* informing life.

4. The universe seems to be all alive with one life manifesting itself in an infinite variety of ways and forms. Man seems to be inherently a spiritual solidarity within that one life. Of all the manifestations of man, art seems to exhibit the inner unity of man, his inner identity, the articulation and relationship and harmonious interplay and accommodation of all the parts in a functioning unity.

CONCLUSION

Art at its highest is not only a creative adventure into a realm beyond that of our everyday concerns, pointing toward a greater and more inclusive reality, but also a power at work in mankind, a power making for greater understanding of universal values, of the hidden meaning of life, thus directing man nearer to a sensible and just solution of his problems. But, for this, each age and each people must rediscover in terms of first-hand, direct experience its entrance into the greater and enduring life that overshadows our mundane existence and puts us *en rapport* with the timeless expressions of the summit of the spirit of man in all ages and places.

This is done by creative adventure in the arts – a process of turning ourselves inside out. That is, total environment evokes in us the need to discover living values that increase the depth of our awareness; it leads us both to find ourselves in our environment and to give that environment new and more far-reaching meaning.

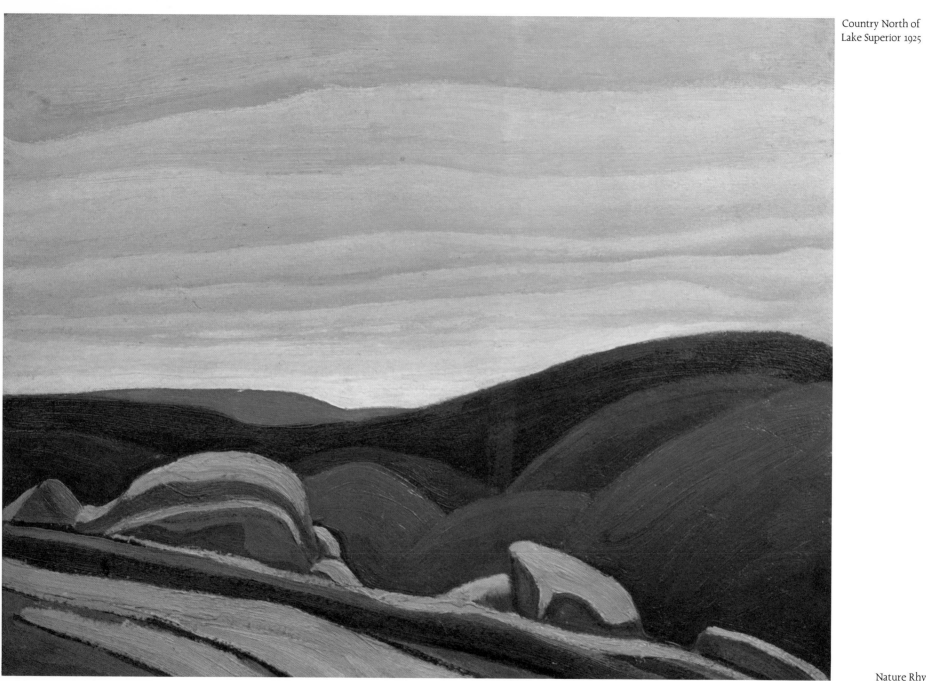

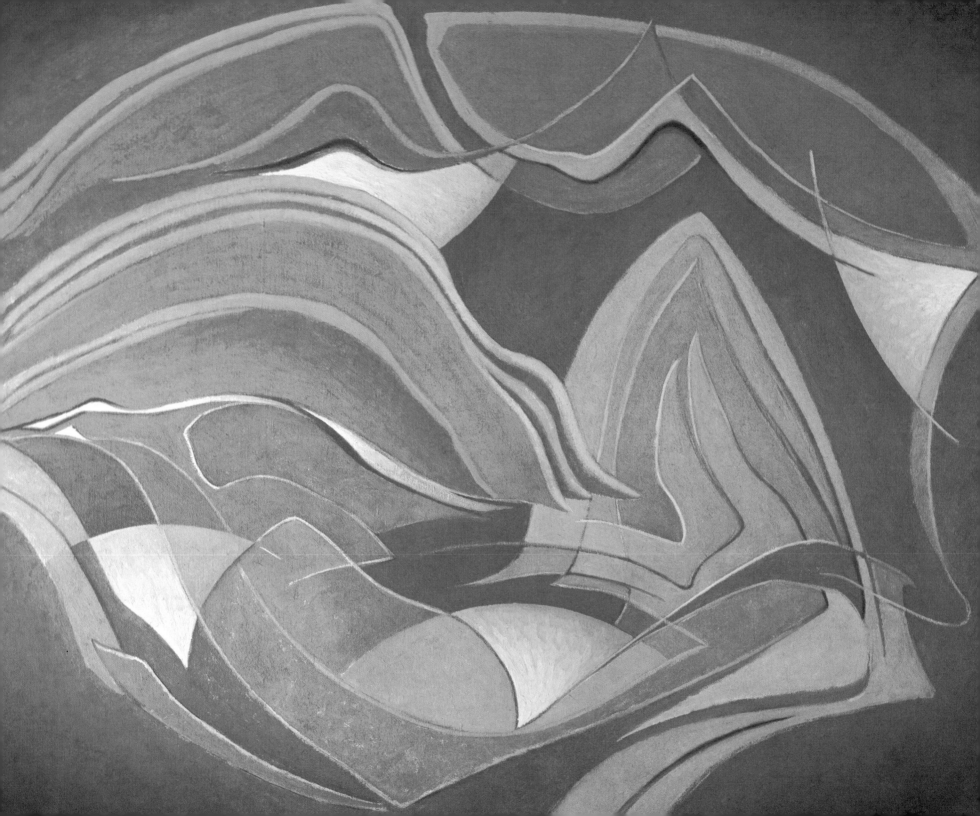

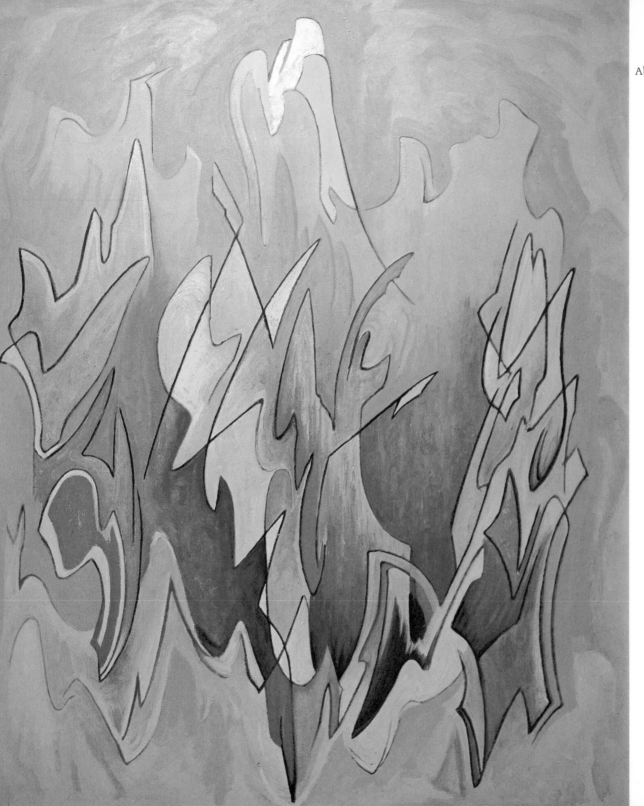

Abstraction 1950-5

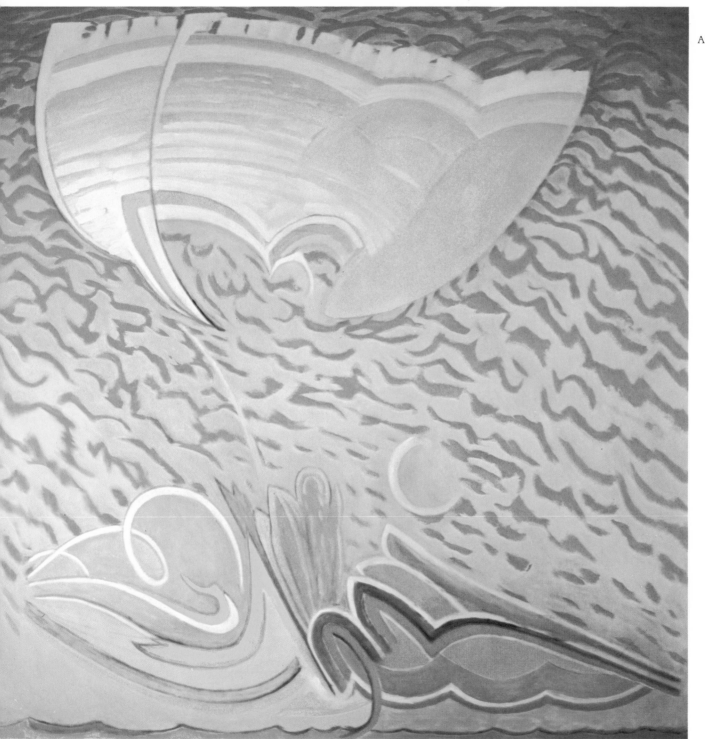

Abstraction 1957

The purpose of painting abstracts is different from that in landscape painting; it has to do with movements, processes, and cycles in nature.

One abstract painting of this kind is thus meant to convey more than is possible in a representational painting.

Abstract painting cannot be done in a mechanical way.
It is done more in terms of a dance of the spirit.
Its discipline is the discipline of a cosmic dance —
Or in the rhythm of living exfoliating flowers.
The one role is that the work of art is autonomous,
A living and satisfying relationship within itself.

No one element, line or colour is static —
Each leads into another.
All is movement,
Though there may be hesitancies, slowing down,
A seeming culmination in the over-all on-going pace —
As in music.

In all great art, there is, of course, movement:
The line around a face, a figure or group of figures,
The moving boundary of one colour against another,
The lines of robes and costumes, trees, houses, hills.
But the forms are fixed.
There is pace in every good painting, the pace of all the different
Colour areas and the fluctuation of colours in costumes, skies, objec
But in the kind of painting I am trying to describe,
There are no final forms nor objects,
No central point, no one place of focus.
There are, of course, partial forms and shapes in the movement, bu
The form is the totality of the movement.

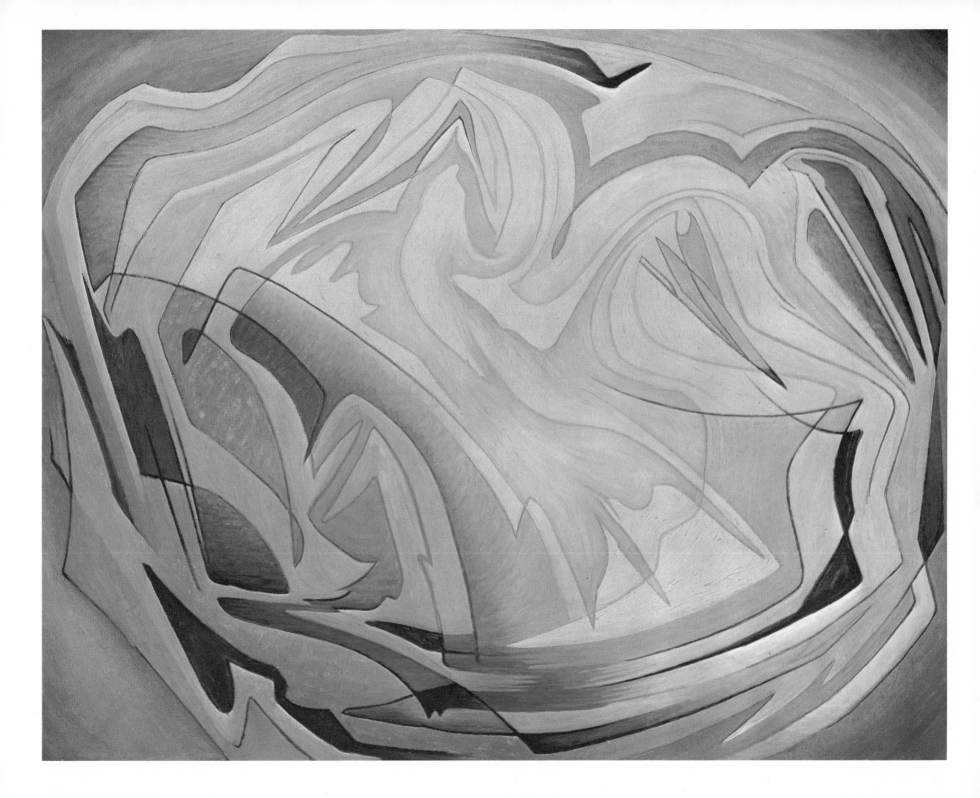

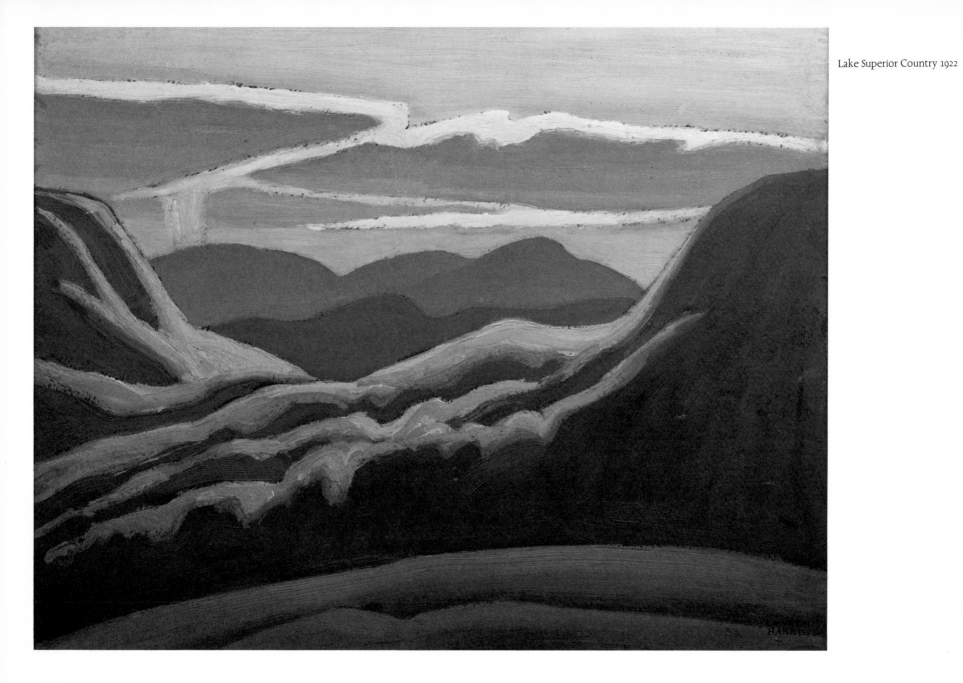

Lake Superior Country 1922

Day and Night

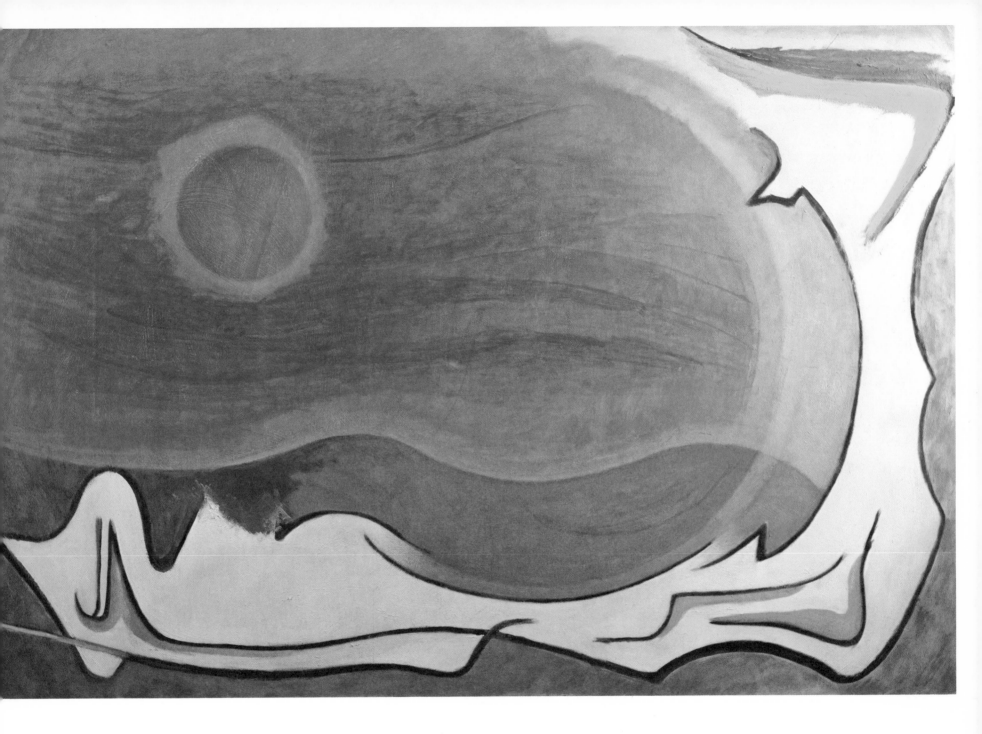

Creative life results from an interplay of two or more planes – as the plane of emotion, of experience outer or inner, and of active mentality.

The solution in the sense of resolution or liquidation of anything occurs in living momentum in the interplay of activity on two or more planes, is impelled into momentum by friction of two or more planes: emotional, mental, or psychic.

All life is a paradox, a contradiction, which means that any productive experience results from the fluid interplay of two planes, two forces, a pair of opposites; and results are therefore unpredictable from any one plane.

From one point of view, the pairs of opposites are more than a paradox – they are antithetical, even rule one another out. From another point of view they are productive in activity of structure, of pattern, of experience. From still another point of view, that of sympathetic vision, they are the essentials of harmony, or they can be the essentials of harmony. All works of art embody, exemplify this. For they express a unity, an evenness of impact, and yet this is achieved by opposing forces, by many contrasts.

Spiritual implication results from our harmony of forces that from any one plane seem mutually exclusive, incompatible, antithetical. Hence the dislike of the word spiritual, or of spirituality itself, by the specialist in lust, theory, system, intellect, cynicism.

There are many levels of life, each with its own reality: the reality of physical facts and conditions, the reality of our emotional life and even a promise of a genuine science of the emotions, and the reality of the intellect which analyses and relates and categorizes. And all of these may be viewed by the creative intelligence and imagination which functions on another level still.

Mankind embodies, and can and will express in the arts, an infinite variety of ways of seeing, of vision. The impulsion of the three evolutions – physical, mental, and spiritual – is toward a greater and greater expansion of understanding ever pressing for expression; and no one can foresee all of the next unfolding.

The pain involved in any creative venture in the arts occurs in the wide gap between what we feel and see and its realization in an actual work of art. But our aspiration and vision have to be away ahead of our performance. And yet, no matter how many times we fail to bring our performance within hailing distance of our vision, we must never give up. The real basis and urge of the arts is divine discontent.

Abstraction 1958

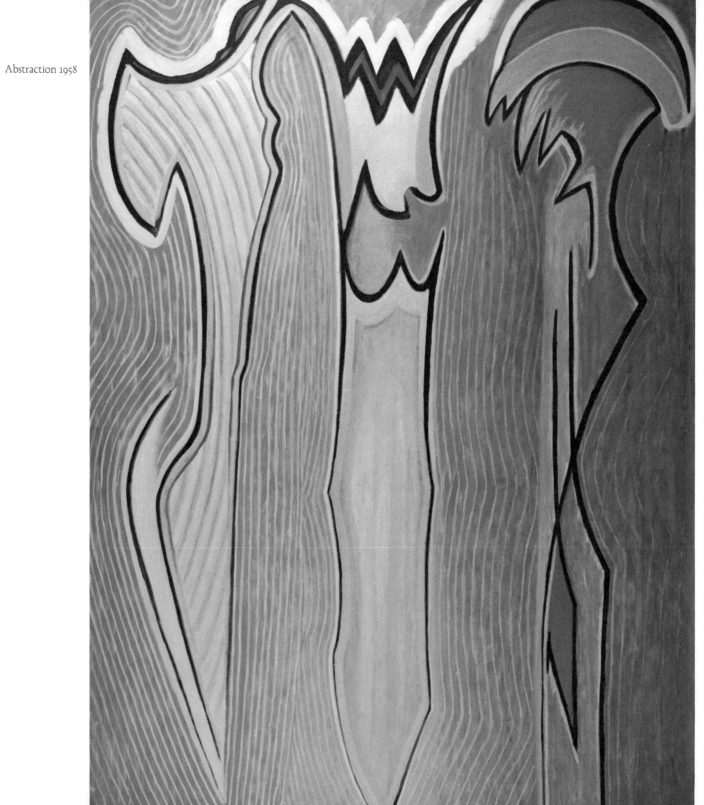

All creative activity in the arts is an interplay of opposites, and it is the union of these in a work of art that gives it vitality and meaning.

The principles of art – the aesthetic side – the appropriateness of each part to the total expression – the all-over harmony and balance – result in a unified functioning of everything in the work, until it becomes like a watch in its structure and organization. Without this it cannot hold the full and appropriate expression of the idea, mood, or spirit which was its inspiration. The purpose, however, is different from that of the watch. The watch is a mechanism for measuring time. The structure of a work of art is made to house a living experience. And this structure in all its related parts and as a totality also expresses a philosophy. Indeed, it cannot help but do so. For if it is a real work of art, it is a symbol of dynamic, universal order.

The life stories of all great creative individuals in the arts – and the illimitable reaches of creative experience itself – all point to the idea that the creative spirit in man and the creative spirit in the universe are one and the same.

How often do we have to discover that work is the great release? When we are stuffy, over-crowded with ugliness and with tendencies to belittle and disparage, we should commence some work, any work. Any positive work starts an inner activity, a flowing that clears away muddiness and brings a return of goodwill. Even to go to a show, listen to music, talk with others will shake us out of the poisonous ferment of stagnation. This gives us a hint of the joy and freedom behind the creative process. It also shows us that we are not what we think we are. Our potentiality is infinite. . . . And so we come to see that the more powerful the individual, the greater his or her creative capacity, the greater the need for work, whether with hands, thought, or feelings, or all three. The immense amount of works left by great creative individuals came from a great necessity in their natures.

An artist should be humble before the infinite beauty of the Universal Soul, and obsessed by creative enthusiasms. The balance of these two is of the enduring spirit, irrespective of the creative medium.

There is a division in man's nature: the mood of the down-to-earth or the daily grind, and the idealizing or visionary side; this division is inescapable and sometimes painful; it is part of the great creative interplay of life without which a full-rounded character of understanding and compassion cannot be achieved. We are all schizophrenics to varying degrees, all of us who are neither congenital animals nor authentic saints.

Every great work of art when experienced evokes both humility and elevation in the onlooker; this great experience is evoked by the aesthetic devotional experience embodied at its best in the work of art.

This is why the very essence, the informing spirit of all great art is impersonal – even though the particular way the words, music, or paint is used *is* personal to the man who created it – and bears his imprint.

If the personal *should* predominate, then only those who share that particular person's outlook will find satisfaction in his work.

But if a universal life shines through the personal imprint – it then becomes possible for you and me and all men to participate in the one great experience.

In so far as the artist *is* creative, he serves something greater than his personal self.

Furthermore, given knowledge and skill in his art – then the greater his concentration, and his service to the inner creative power, the more luminous will be the universal quality in his work.

For only a great devotion can create nobly – can arrive at a full meaning that is universal.

It is thus that creative life in the arts opens a door to the living spirit.

In these terms, it seems that our consciousness has the possibility of limitless sweep, limitless experience. Perhaps we are linked in every part and phase to the greater life of the universe. Perhaps the arts may help us realize that creative life in us and the informing spirit which sustains the great universe are one and the same.

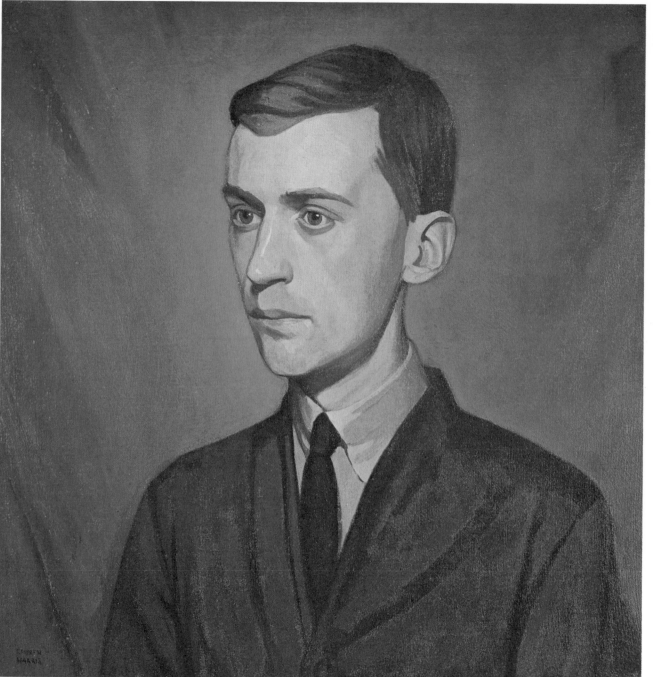

Thoreau MacDonald 1927

Dr. Salem Bland 1926

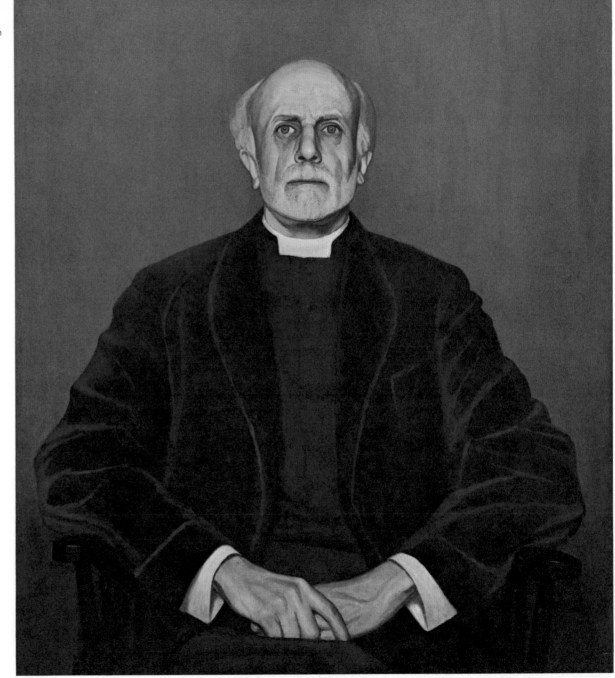

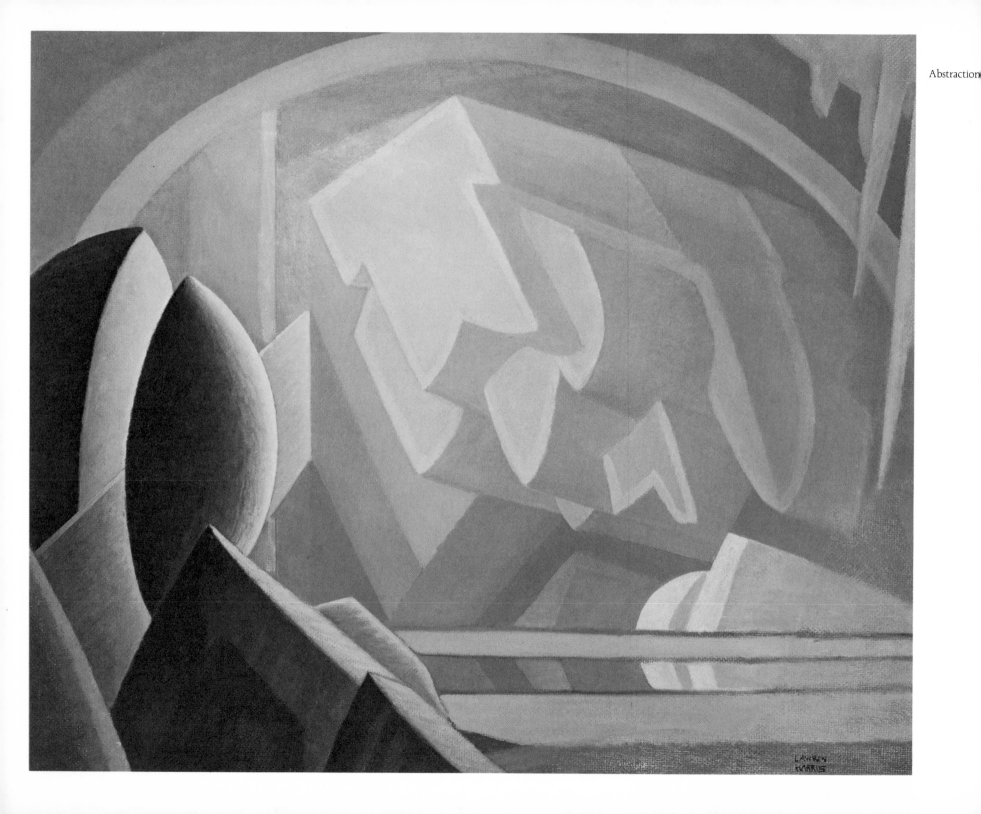

And yet, though everything in the painting is in movement,
There is or can be an overtone of expressive content
Which is more profound, moving or exhilarating
Than in a static or fixed or architectonic composition —
Or should I say different from these?
This may be because movement implies rest.
The rest or peace implicit in such paintings,
 however active or dynamic they may be,
 is in the balance of the over-all movement
In colour, line, mass, and their relationships.

In non-objective painting we are freed from our associa-
tions, released into a realm wherein we can experience
away from the here and now, and thus enlarge our
life gamut.

The primary function of art is not to imitate or repre-
sent or interpret, but to create a living thing; it is the
reduction of all life to a perfectly composed and dynamic
miniature — a microcosm where there is a perfect balance
of emotion and intellect, stress and strain resolving
itself, form rhythmically poised in three dimensions.

 So long as painting deals with objective nature, it is
an impure art, for recognizability precludes the highest
aesthetic emotion. All painting, ancient or modern,
moves us aesthetically only in so far as it possesses a
force over and beyond its aspect.

If this fog would lift but for a moment,

This fog we live in and are lost in, close-hugging us in pain,

This seething fog, weighted with prejudices, dense with the close-packed particles of selfishness, crowding
 vision into blindness,

We would see some strange sights, some wonderful sights – so many welcoming smiles,

And we would hear some strange sounds, some wonderful sounds – so many welcoming voices; such music!

There would be people greeting one another with all-embracing smiles, forgotten smiles, quite guileless.

And there would be great hand-clasps, a majestic look in the eyes.

And there would be people falling into one another's arms in unimaginable relief.

And there would be eyes brimming over with tears, welling up from the depths where profound
 recognition resides.

And there would be salutations encircling the globe like swift clean breezes, freshening its tired air.

So many old acquaintances, friends, companions, lost lovers found.

Ages old, great places, great regions of childhood, youth and freedom regained.

Endless reunions attained with but simplicity of vision.

Multitudinous meetings in less than the wink of an eye.

And great home-comings without the least journeying.

from Contrasts, 1922

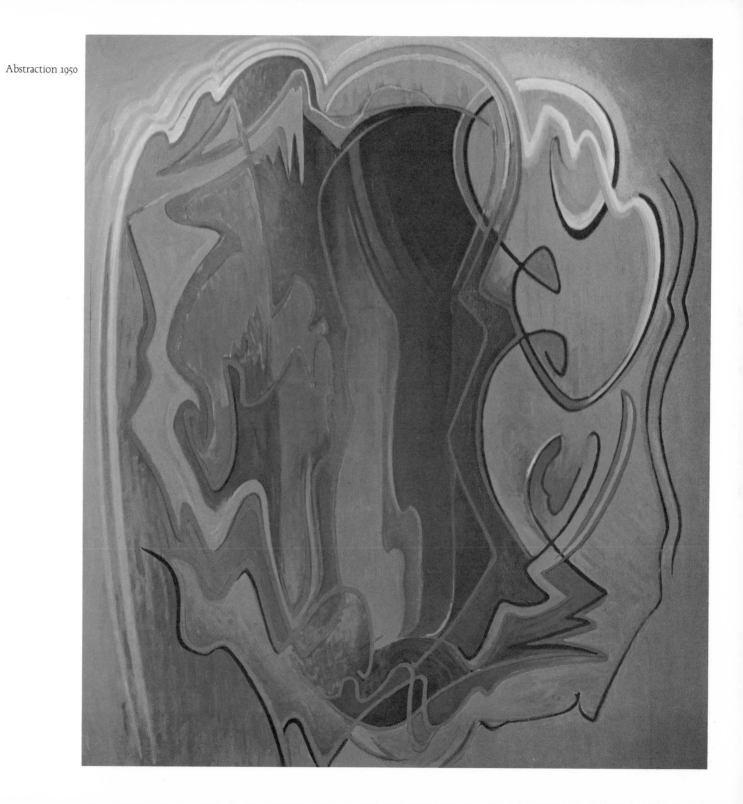

Abstraction 1950

Only by undeviating concentration can an artist clarify what he is doing. If the work becomes so clear and meaningful to him, then it is bound to become clear and meaningful to a receptive and perceptive onlooker in the degree of his sensibility. There is no other way.

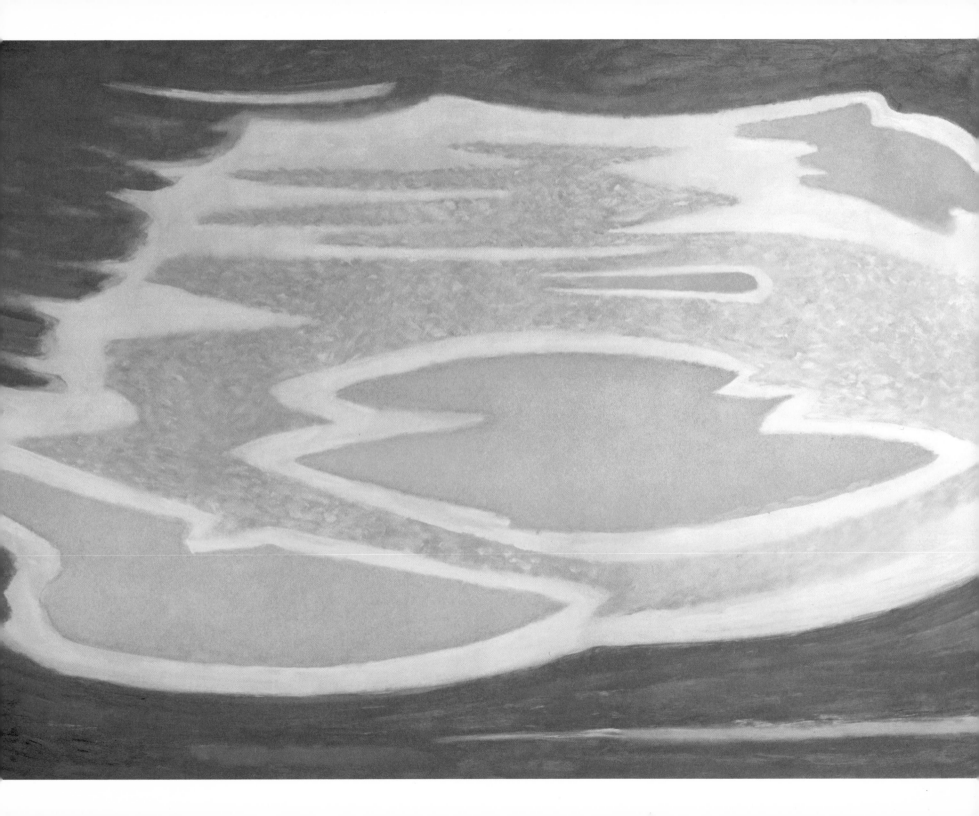

The greatest art does not represent or interpret life: moods, feelings, thoughts, things; it is life, created life, the expression and the projection of life, the reduction of all life to a perfectly composed miniature — a micro-cosm. We may enjoy the superficialities in art: beauty of surface, choice of subject, technique, moods, joy, sorrow, melancholy, etc., but we must relate these qualities in art correctly, and in order and valuation, that our judgment may be broader and more profound.

Abstraction 1937

The creative artist in every productive age has always made the styles of his day and place. *Expressionism*, however, is not a style, like impressionism, cubism, magic realism, surrealism, or geometrical abstraction. It is, as I said, a new realm of art wherein every modern artist creates his own style — and it has thus revivified representational painting because of the evocative demands of new creative vision. So we have today new creations of experiences of nature, of ideas and intimations and perceptions of the inner world of man, of inner motivations and reactions to life on all levels, given life by pictorial means.

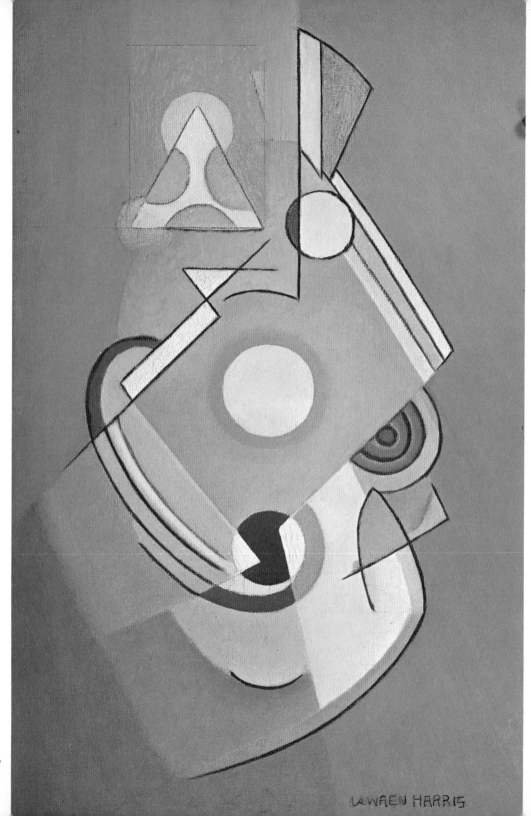

Abstraction 1937

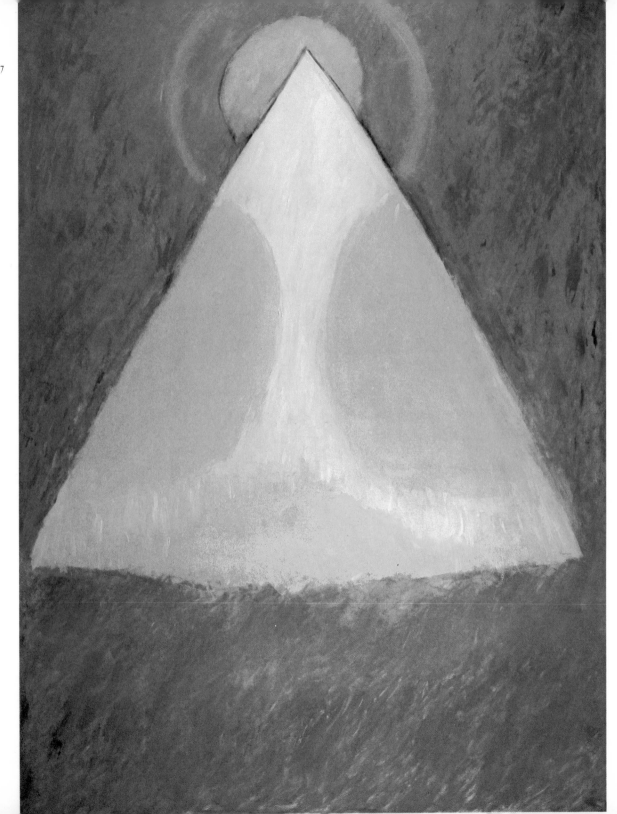

Abstraction 1967

In the inner place where true artists create there exists a pure child. To recognize this is to recognize beauty as a living, abiding presence completely untouchable by all the devices of man, such as moral codes, creeds, intellectual analysis, games and clichés, the acquisitive instinct, or lust for anything whatsoever.

The real inner world of art is a pure world, my friends, and all manifestations of life seen from this world look ugly or beautiful – beautiful if simple and true, ugly if devious, weak, grasping, mean, or little.

Every genuine artist protects this child, his real self, from all possible impingements. He may resort to any form of anarchy, even of wildness, to do so because of the great contrast of strain he is in, for the world as men generally know it with its mechanisms and defences, protections and hypocrisies, social regimentation and codes is as nothing in his sight. Only beauty of soul has for him any meaning.

And this is impersonal, though its recognition does thrill through the personality and transforms it. The child, the real self of the artist, is impersonal. This may sound strange, but it is so. His heart is simple joy, but it is surrounded by sadness – sadness at the clutter of meaninglessness both in himself and in his fellow man.

The child is pure perception without encumbrances, without sophistication, without any of the warping little values that clutter the life of man. And to understand art, which is to say the experience of art in its inner abiding reality, you must become that child of wonder.

That child is not only humble and exalted, gentle and severe, but a balance of all these in pure unified being.

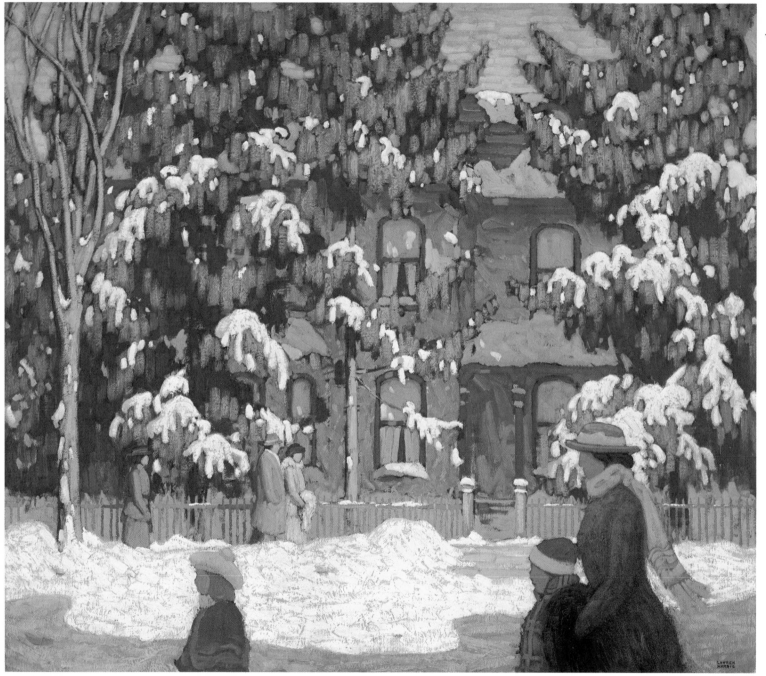

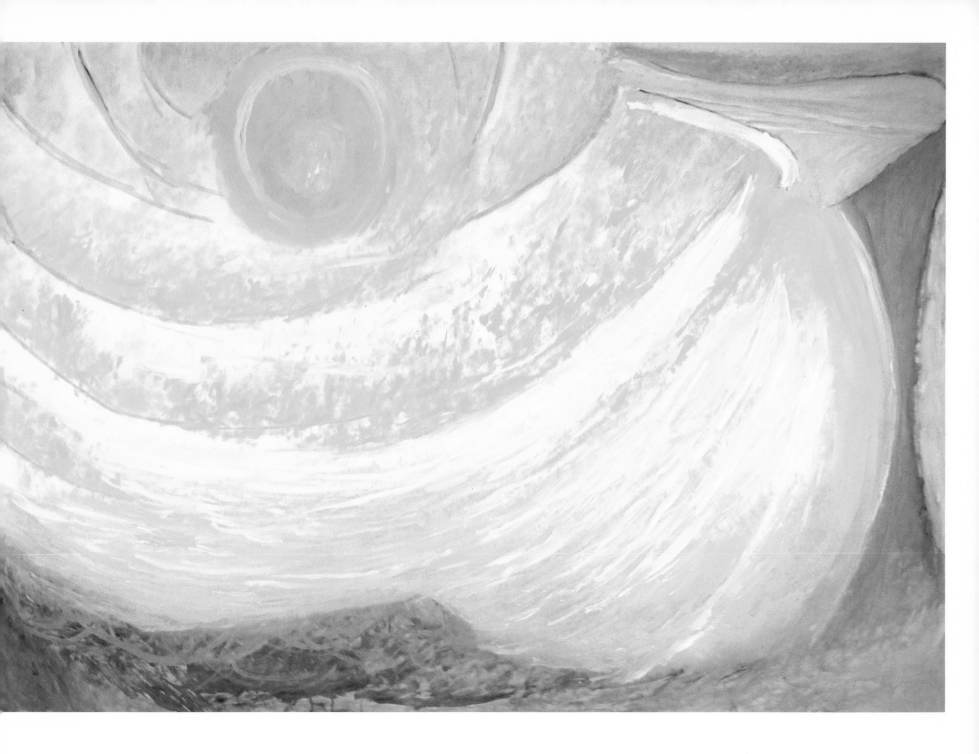

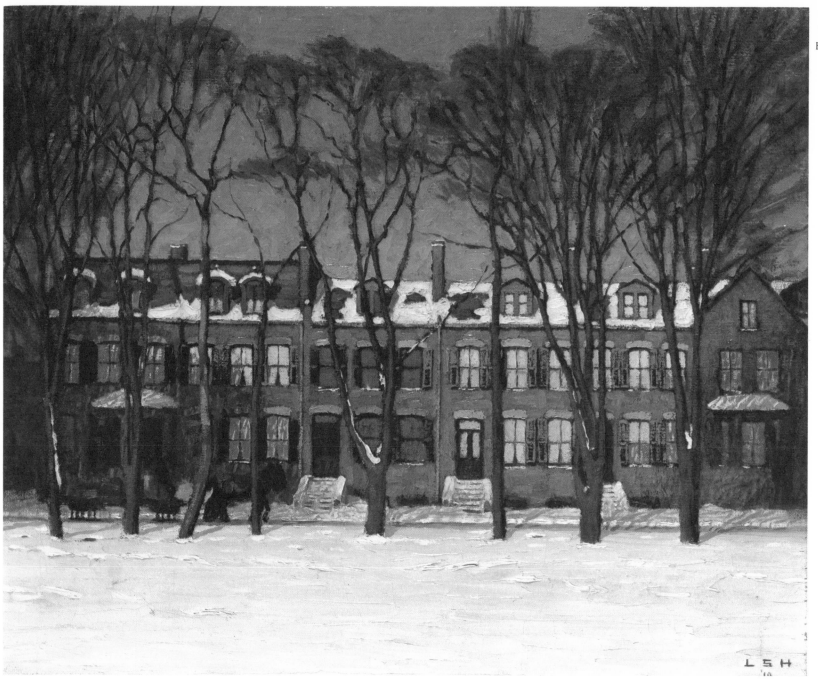

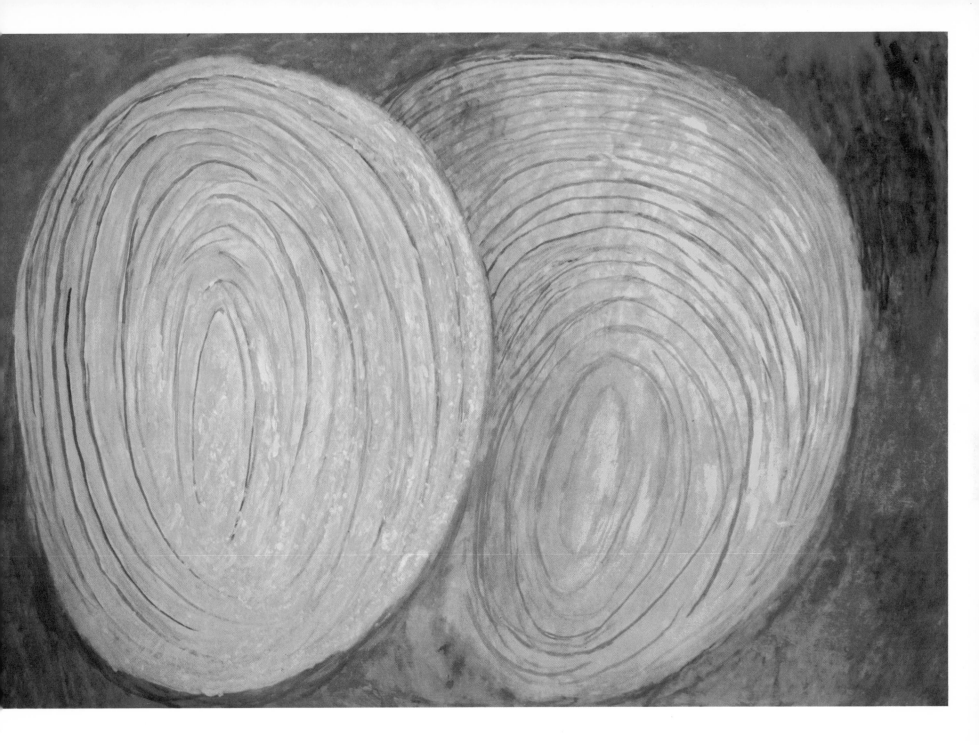

138 There is no finality, no final statement; everything remains to be re-created by every creative artist.

It must be that all possibilities, all directions, all courses in nature and in man have to be explored, manifested, and exhausted. We live only when we adventure and give expression to the results of our adventure. So we permit all rules, conventions, institutions, and prohibitions to become stable only that we may thereby have a base from which to adventure further, a working-place wherein to give form to our findings, and a resting-place wherein to recuperate from past efforts and acquire energy for further adventure.

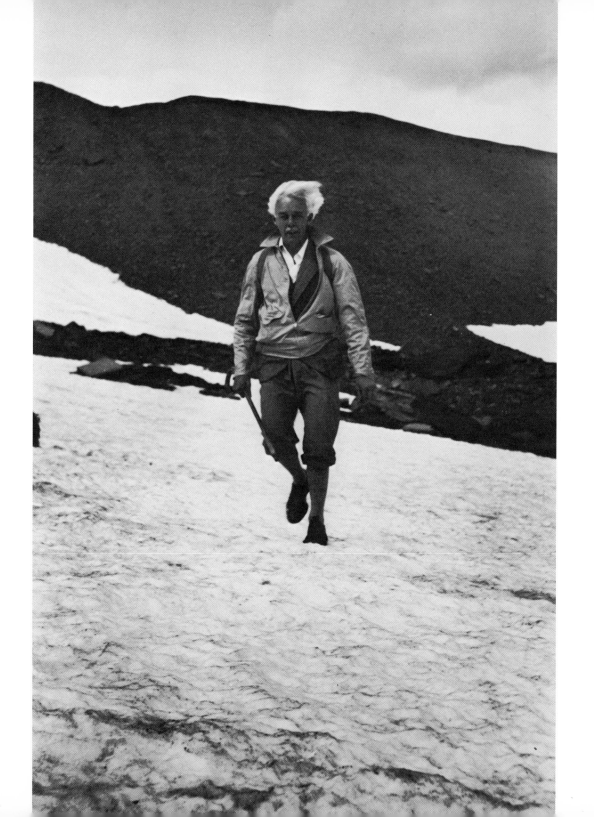

Chronology

On October 23, 1885, Lawren Harris was born to Anna and Thomas Harris in Brantford, Ontario.
He attended school and university in Toronto.

In the autumn of 1904 he went to Germany to study painting.
He returned to Canada in the summer of 1907.
In 1909 he travelled with Norman Duncan from Beersheba to Damascus, mostly by camel, painting for *Harper's* Magazine and for Norman Duncan's articles.
In 1910 he went to northern Minnesota where he painted in lumber camps and also for *Harper's* Magazine.

His first studio in Toronto was over a grocery store at the corner of Yonge and Cumberland streets.
In 1910 he painted 'Houses on Wellington Street' which was exhibited with the Ontario Society of Artists in 1911 and is reproduced on page 136.
During the years 1910-14 he painted houses and corner stores (with hurdy-gurdies, sleighs, horses, and people) in the Ontario towns of Hamilton, Unionville, Barrie, Grimsby, and Toronto. The Ontario landscape was painted in Algonquin Park, at Lake Simcoe, in Haliburton, and around Mattawa on the Ottawa River.

In 1914 the Studio Building on Severn Street, Toronto, was opened. A few years were spent in the army. In 1917, when he received his discharge, he went to Georgian Bay, to Manitoulin Island, and to Michipicoten.
In 1918, 1919, and 1920 the month of October was spent painting in Algoma.
In 1921 he visited and painted in Halifax and Newfoundland.
In 1921 and until 1926 the autumn sketching-ground was on the shore of Lake Superior.
Houses and street scenes continued to be painted.
In 1920 the first of eight portraits was painted; the last portrait was of Thoreau MacDonald, painted in 1927 or 1928.
1924 was the first of five summers spent in the Canadian Rockies. Jasper, Maligne Lake, Tonquin Valley, Lake Louise, Moraine Lake, Lake O'Hara, Yoho, Emerald Lake, and the remote Mount Robson were the areas in which he climbed and worked.

While painting in the mountains he felt the need and urge to move into the abstract idiom. In the studio during the winter months experimentation began.
In 1930 he spent the summer on board S.S. *Beothic* in the Arctic Seas – a guest of the Canadian government. The work on pages 83 to 85 developed from sketches made during that voyage.
In the studio, experimentation in the abstract continued.
From 1934 to 1938 he lived in Hanover, New Hampshire. There he painted a few transitional works – 'The Bridge' (page 5) and 'Winter Comes from the Arctic to the Temperate Zone' (page 97) and a few small paintings of the White Mountains and of houses in Hanover. The large works were abstractions.
In 1936 his first exhibited abstraction, 'Riven Earth I' (page 108), was shown with the Canadian Group of Painters.
It was during these years that he first thought of writing a book. Notes were made and some chapters were begun.
From 1938 to 1940 he lived in Santa Fe, New Mexico. The altitude there is 7,000 feet – the air is clear, the colours high in key. Clear-cut forms in space came into the work done while he was living there.

In 1940 he moved to Vancouver. 'Composition No. 1' (page 105) was the first work painted in the new studio. The Canadian Rockies were again visited in the summers. 'Mountain Spirit' (page 92), 'Mt. Ann-Alice' (page 90), and 'Mountain Experience' (page 93) came from the renewal of contact with the Robson country.
The ancient philosophy of the East has been a motivating power in the work of Lawren Harris. Landscape and abstract compositions are both permeated by the awareness of life as a spiritual energy. He wrote, 'My own experience has been that art is a voice of the undying and unquenchable spirit in man.'

List of Paintings

Unless otherwise stated, the paintings are from the collection of the artist or that of his wife. After 1920, paintings have rarely been dated by the artist. Oil was the only medium used. The large paintings are on canvas; the smallest paintings (sketches) are on board. Dimensions (height followed by width) are in inches.

Title and date	Dimensions	Owner in 1969	Page
The Bridge 1937	15 x 12	R. G. P. Colgrove, Toronto	5
North Labrador 1930	12 x 15		8
Northern Image 1950	46 x 49	University of British Columbia, Vancouver	9
Lake Superior IX 1923	42½ x 50	Dr. John A. MacAulay, Winnipeg	12
Above Lake Superior 1924	48 x 60	Art Gallery of Ontario, Toronto	13
Abstraction 1938	55½ x 34½		15
Abstraction 1950	48½ x 37		17
Maligne Lake, Jasper Park 1924	48 x 60	The National Gallery of Canada, Ottawa	19
Building the Ice House 1912	10½ x 12½		23
In the Ward 1916	10½ x 13¾		25
House in the Ward 1917	10½ x 13½		27
A Side Street 1919	36 x 44	Willistead Gallery, Windsor, Ontario	29
Shacks 1919	42 x 50¼	The National Gallery of Canada, Ottawa	31
Billboard 1922	42¼ x 50¼		33
Miners' Houses, Glace Bay 1921	43 x 51	C. S. Band, Toronto	35
Houses 1913	32 x 36	J. C. Fraser, Toronto	36
In Memoriam to a Canadian Artist 1950	40 x 40	R. G. P. Colgrove, Toronto	42
Wood Interior, Algoma 1918	10½ x 13¾		46
Agawa Falls 1918	10½ x 13¾		47
Tamarack Swamp 1922	42¼ x 58¼		49
North Shore, Lake Superior 1926	40 x 50	The National Gallery of Canada, Ottawa	53
Pic Island, Lake Superior 1924	48 x 59¾	Colonel R. S. McLaughlin, Oshawa, Ontario	54
Pic Island 1925	49 x 63		57
Clouds, Lake Superior 1923	40¼ x 50	Winnipeg Art Gallery	59